# FABLES OF ÆSOP
### ACCORDING TO SIR ROGER L'ESTRANGE

# FABLES OF ÆSOP
## ACCORDING TO SIR ROGER L'ESTRANGE

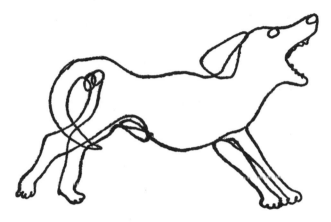

### WITH FIFTY DRAWINGS BY
# ALEXANDER CALDER

DOVER PUBLICATIONS, INC.

NEW YORK

Published in Canada by General Publishing Company, Ltd., 30 Lesmill Road, Don Mills, Toronto, Ontario.

Published in the United Kingdom by Constable and Company, Ltd., 10 Orange Street, London WC 2.

This Dover edition, first published in 1967, is an unabridged and unaltered republication of the work originally published by Harrison of Paris in 1931. A new publisher's note replaces the one which appeared in the original edition.

*Library of Congress Catalog Card Number: 67-14002*

Manufactured in the United States of America
Dover Publications, Inc.
180 Varick Street
New York, N. Y. 10014

## PUBLISHER'S NOTE

THIS volume is a reproduction of a limited edition of 665 copies, designed by Monroe Wheeler and published by him and Barbara Harrison under the imprint of Harrison of Paris in 1931. The text is Sir Roger L'Estrange's retelling of the traditional fables, dated 1692. In order to preserve the savor of his seventeenth-century diction, the old spelling has been retained, but for the sake of legibility the arbitrary use of capitals and italics has not been followed. The drawings of Alexander Calder were created by him for that edition, and an original drawing was included in each of fifty special copies.

1967

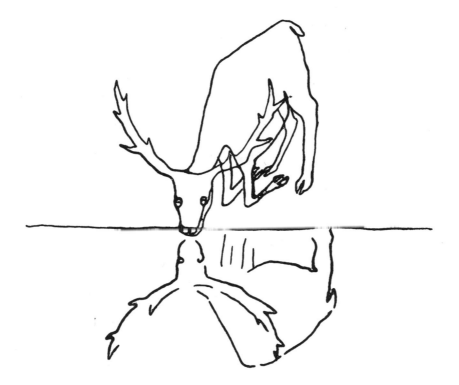

## A STAG DRINKING

AS a stag was drinking upon the bank of a clear stream, he saw his image in the water, and entered into this contemplation upon't. Well! says he, if these pityful shanks of mine

were but answerable to this branching head, I can but think how I should defy all my enemies. The words were hardly out of his mouth, but he discover'd a pack of dogs coming full-cry towards him. Away he scours cross the fields, casts off the dogs, and gains a wood; but pressing thorough a thicket, the bushes held him by the horns, till the hounds came in, and pluck'd him down. The last thing he said was this. What an unhappy fool was I, to take my friends for my enemies, and my enemies for my friends! I trusted to my head, that has betray'd me, and I found fault with my leggs, that would otherwise have brought me off.

THE MORAL
*He that does not thoroughly know himself, may be well allowed to make a false judgment upon other matters that most nearly concern him.*

## A LYON, ASS AND FOX

AS an ass and a fox were together upon the ramble, a lyon meets them by the way. The foxes heart went pit-a-pat; but however, to make the best of a bad game, he sets a good face on't, and up he goes to the lyon. Sir, says he; I am come to offer your majesty a piece of service, and I'll cast myself upon your honour for my own security. If you have a mind to my companion, the ass here, 'tis but a word speaking, and you shall have him immediately. Let it be done then says the lyon. So the fox trepann d the ass into the toyl, and the lyon, when he found he had him sure, began with the fox himself, and after that, for his second course, made up his meal with the other.

THE MORAL
*We love the treason, but we hate the traytor.*

2

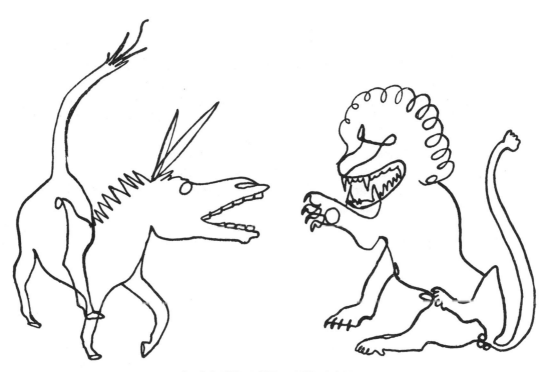

## A LION AND AN ASSE

AN asse was so hardy once, as to fall a mopping and braying at a lyon. The lyon began at first to shew his teeth, and to stomack the affront; but upon second thoughts; well! (says he) jeer on, and be an asse still. Take notice only by the way, that 'tis the baseness of your character that has sav'd your carcass.

### THE MORAL

*It is below the dignity of a great mind to entertain contests with people that have neither quality nor courage : beside the folly of contending with a miserable wretch, where the very competition is a scandal.*

3

# A FARMER AND HIS DOGS

A CERTAIN farmer was put to such a pinch in a hard winter for provisions, that he was forc'd to feed himself and his family upon the main stock. The sheep went first to pot; the goats next; and after them, the oxen; and all little enough to keep life and soul together. The dogs call'd a councel upon't, and resolv'd to shew their master a fair pair of heeles for't, before it came to be their turn; for (said they) after he has cut the throats of our fellow servants, that are so necessary for his bus'ness, it cannot be expected that he will ever spare us.

### THE MORAL

*There's no contending with necessity, and we should be very tender how we censure those that submit to't. 'Tis one thing to be at liberty to do what we would do, and another thing to be ty'd up to do what we must.*

# AN OLD TREE TRANSPLANTED

A CERTAIN farmer had one choice apple-tree in his orchard that he valu'd above all the rest, and he made his landlord every year a present of the fruit on't. He lik'd the apples so very well, that nothing would serve him but transplanting the tree into his own grounds. It withered presently upon the removal, and so there was an end of both fruit and tree together. The news was no sooner brought to the landlord, but he brake out into this reflexion upon it : This comes, says he, of transplanting an old tree, to gratifie an extravagant appetite : whereas if I could have contented my self with the fruit, and left my tenant the tree still, all had been well.

### THE MORAL

*Nature has her certain methods and seasons for the doing of everything, and there must be no trying of experiments to put her out of her course.*

4

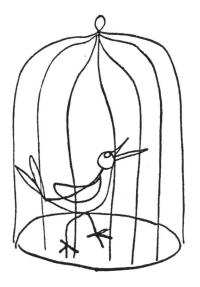

## A NIGHTINGALE AND A BAT

AS a nightingale was singing in a cage at a window, up comes a bat to her, and asks her why she did not sing in the day, as well as in the night. Why (says the nightingale) I was catch'd singing in the day, and so I took it for a warning. You should have thought of this then, says t'other, before you were taken; for as the case stands now, y'are in no danger to be snapt singing again.

### THE MORAL

*A wrong reason for the doing of a thing is worse then no reason at all.*

## FISHING IN TROUBLED WATERS

A FISHER–MAN had order'd his net, for a draught, and still as he was gathering it up, he dash'd the water, to fright the fish into the bag. Some of the neighbourhood that look'd on, told him he did ill to muddle the water so, and spoil their drink. Well (says he) but I must either spoil your drink, or have nothing to eat my self.

### THE MORAL

*There's no engaging the mobile in a sedition till their heads are so muddled first with frights and visions, that they can neither see, hear, nor understand.*

5

## JUPITER AND A HERDS–MAN

A HERDS–MAN that had lost a calf out of his grounds, sent up and down after it; and when he could get no tydings on't, he betook himself at last to his prayers, according to the custom of the world, when people are brought to a forc'd put. Great Jupiter (says he) do but shew me the thief that stole my calf, and I'll give thee a kid for a sacrifice. The word was no sooner pass'd; but the thief appear'd; which was indeed a lyon. This discovery put him to his prayers once again. I have not forgotten my vow, says he, but now thou hast brought me to the thief, I'll make that kid a bull, if thou'lt but set me quit of him again.

### THE MORAL
*We cannot be too careful and considerate what vows, and promises we make; for the very granting of our prayers turns many times to our utter ruine.*

## A PIGEON AND A PICTURE

A PIGEON saw the picture of a glass with water in't, and taking it to be water indeed, flew rashly and eagerly up to't, for a soup to quench her thirst. She broke her feathers against the frame of the picture, and falling to the ground upon't, was taken up by the by-standers.

### THE MORAL
*Rash men do many things in hast that they repent of at leisure.*

## A BOY AND COCKLES

S OME people were roasting of cockles, and they hiss'd in the fire. Well (says a block-headed boy) these are villanous creatures sure, to sing when their houses are a-fire over their heads.

### THE MORAL
*Nothing can be well that's out of season.*

6

# A FOX AND A CARV'D HEAD

AS a fox was rummidging among a great many carv'd figures, there was one very extraordinary piece among the rest. He took it up, and when he had consider'd it a while, well, (says he) what pity 'tis, that so exquisite an outside of a head should not have one grain of sense in't.

### THE MORAL

*'Tis not the barber or the taylor that makes the man; and 'tis no new thing to see a fine wrought head without so much as one grain of salt in't.*

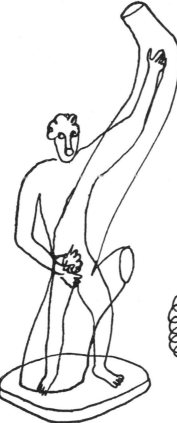

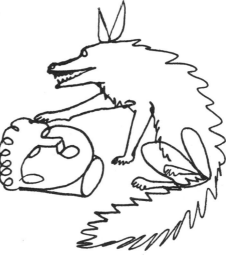

## JUPITER AND MODESTY

MAN was made in such a hurry (according to the old fable) that Jupiter had forgotten to put modesty into the composition, among his other affections; and finding that there was no way of introducing it afterwards, man by man, he propos'd the turning of it loose among the multitude. Modesty took her self at first to be a little hardly dealt withal, but in the end, came over to agree to't, upon condition that carnal love might not be suffer'd to come into the same company; for wherever that comes, says she, I'm gone.

THE MORAL

*Sensual love knows neither bars nor bounds. We are all naturally impudent; only by custom, and fig-leaves, we have been taught to disguise the matter, and look demurely; and that's it which we call modesty.*

## A BEE–MASTER

THERE came a thief into a bee-garden in the absence of the master, and robb'd the hives. The owner discovered it upon his return, and stood pausing a while to be-think himself, how this should come to pass. The bees, in this interim, came laden home out of the fields from feeding, and missing their combs, they fell powdering in swarms upon their master. Well (says he) you are a company of senceless and ungrateful wretches, to let a stranger go away quietly that has rifled ye, and to bend all your spite against your master, that is at this instant beating his brains how he may repair and preserve ye.

THE MORAL

*'Tis the curse of the world for people to take their friends for their foes, and to use them accordingly.*

8

## A HARE AND A TORTOISE

WHAT a dull heavy creature (says a hare) is this same tortoise! And yet (says the tortoise) I'll run with you for a wager. 'Twas done and done, and the fox, by consent, was to be the judg. They started together, and the tortoise kept jogging on still, 'till he came to the end of the course. The hare lay'd himself down about midway, and took a nap; for, says he, I can fetch up the tortoise when I please : but he over-slept himself it seems, for when he came to wake, though he scudded away as fast as 'twas possible, the tortoise got to the post before him, and won the wager.

### THE MORAL

*Up and be doing, is an edifying text; for action is the bus'ness of life, and there's no thought of ever coming to the end of our journey in time, if we sleep by the way.*

## A CROW AND A RAVEN

YOUR raven has a reputation in the world for a bird of omen, and a kind of small prophet. A crow that had observ'd the raven's manner and way of delivering his predictions, sets up for a foreboder too; and so gets upon a tree, and there stands nodding and croaking, just over the head of some people that were passing by. They were a little surpriz'd at first; but so soon as they saw how 'twas : Come, my masters (says one of the company) let's e'en go forward, for this is but the chattering of a foolish crow, and it signifies nothing.

### THE MORAL

*How are superstitious men hagg'd out of their wits and senses, with the fancy of omens, forebodings, old wives tales and visions; and upon a final examination of the matter, nothing at all in the bottom on't!*

9

# A FOX AND A CRAB

A FOX that was sharp-set, surpriz'd a crab, as he lay out of the sea upon the sands, and carry'd him away. The crab, when he found that he was to be eaten, Well (says he) this comes of meddling where we have nothing to do; for my bus'ness lay at sea, not upon the land.

### THE MORAL

*No body pities a man for any misfortune that befalls him, in matters out of his way, bus'ness, or calling.*

# A MILLER BURYING HIS GOLD

A CERTAIN covetous, rich churle sold his whole estate, and put it into mony, and then melted down that mony again into one mass, which he bury'd in the ground, with his very heart and soul in the pot for company. He gave it a visit every morning, which it seems was taken notice of, and somebody that observ'd him, found out his hoard one night, and carry'd it away. The next day he missed it, and ran allmost out of his wits for the loss of his gold. Well, (says a neighbour to him) and what's all this rage for? Why you had no gold at all, and so you lost none. You did but fancy all this while that you had it, and you may e'en as well fancy again that you have it still. 'Tis but laying a stone where you layd your mony, and fancying that stone to be your treasure, and there's your gold again. You did not use it when you had it; and you do not want it so long as you resolve not to use it.

### THE MORAL

*Better no estate at all, then the cares and vexations that attend the possession of it, without the use on't.*

10

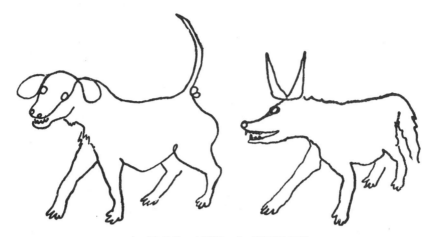

## A DOG AND A WOLFE

THERE was a hagged carrion of a wolfe, and a jolly sort of a gentile dog, with good flesh upon his back, that fell into company together upon the king's high-way. The wolfe wonderfully pleas'd with his companion, and as inquisitive to learn how he brought himself to that blessed state of body. Why, says the dog, I keep my master's house from thieves, and I have very good meat, drink, and lodging for my pains. Now if you'll go along with me, and do as I do, you may fare as I fare. The wolfe struck up the bargain, and so away they trotted together : but as they were jogging on, the wolfe spy'd a bare place about the dogs neck, where the hair was worn off. Brother (says he) how comes this I prethee? Oh, that's nothing, says the dog, but the fretting of my collar a little. Nay, says t'other, if there be a collar in the case, I know better things than to sell my liberty for a crust.

### THE MORAL

*We are so dazzel'd with the glare of a splendid appearance, that we can hardly discern the inconveniences that attend it. 'Tis a comfort to have good meat and drink at command, and warm lodging : but he that sells his freedom for the cramming of his gutt, has but a hard bargain of it.*

## ASSES TO JUPITER

THE asses found themselves once so intolerably oppressed, with cruel masters, and heavy burdens, that they sent their ambassadors to Jupiter with a petition for redress. Jupiter found the request unreasonable, and so gave them this answer : That humane society could not be preserv'd without carrying burdens some way or other : so that if they would but joyn, and piss up a river, that the burdens which they now carry'd by land might be carried by water, they should be eas'd of that grievance. This set them all a pissing immediately, and the humour is kept up to this very day, that whenever one ass pisses, the rest piss for company.

### THE MORAL

*'Tis the uttermost degree of madness and folly, to appeal from providence and nature.*

## A SHEPHERD AND HIS SHEEP

IN old time when sheep fed like hogs upon acorns, a shepherd drove his flock into a little oak-wood, spread his coat under a tree, and up he went to shake 'em down some mast. The sheep were so keen upon the acorns, that they gobbled up now and then a piece of the coat along with 'em. When the shepherd took notice of it : What a company of ungrateful wretches are you, says he, that cloath all other people that have no relation to you, and yet strip your master, that gives ye both food and protection!

### THE MORAL

The belly has no ears; *and a ravenous appetite guttles up whatever is before it, without any regard either to things or persons.*

12

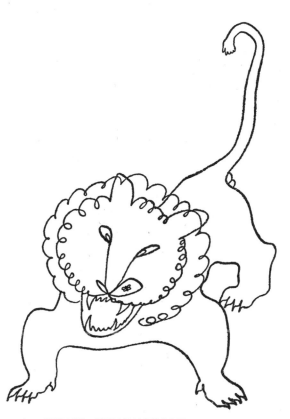

A GNAT CHALLENGES A LYON

AS a lyon was blustering in the forrest, up comes a gnat to
his very beard, and enters into an expostulation with him
upon the points of honour and courage. What do I value your
teeth, or your claws, says the gnat, that are but the arms of
every bedlam slut? As to the matter of resolution; I defy ye to
put that point immediately to an issue. So the trumpet sounded
and the combatants enter'd the lists. The gnat charged into the
nostrils of the lyon, and there twing'd him, till he made him tear

13

himself with his own paws. And in the conclusion he master'd the lyon. Upon this, a retreat was sounded, and the gnat flew his way : but by ill-hap afterward, in his flight, he struck into a cobweb, where the victor fell a prey to a spider. This disgrace went to the heart of him, after he had got the better of a lyon to be worsted by an insect.

<div style="text-align:center">THE MORAL</div>

*'Tis in the power of fortune to humble the pride of the mighty, even by the most despicable means, and to make a gnat triumph over a lyon : wherefore let no creature, how great or how little soever, presume on the one side, or despair on the other.*

## JUPITER'S WEDDING

WHEN the toy had once taken Jupiter in the head to enter into a state of matrimony, he resolv'd for the honour of his celestial lady, that the whole world should keep a festival upon the day of his marriage, and so invited all living creatures, tag-rag and bob-tail, to the solemnity of his wedding. They all came in very good time, saving only the tortoise. Jupiter told him 'twas ill done to make the company stay, and ask'd him, Why so late? Why truly, says the tortoise, I was at home, at my own house, my dearly beloved house, and home is home, let it be never so homely. Jupiter took it very ill at his hands, that he should think himself better in a ditch, then in a palace, and so he pass'd this judgment upon him; that since he would not be perswaded to come out of his house upon that occasion, he should never stir abroad again from that day forward, without his house upon his head.

<div style="text-align:center">THE MORAL</div>

*There's a retreat of sloth and affectation, as well as of choice and virtue; and a beggar may be as proud and as happy too in a cottage, as a prince in a palace.*

14

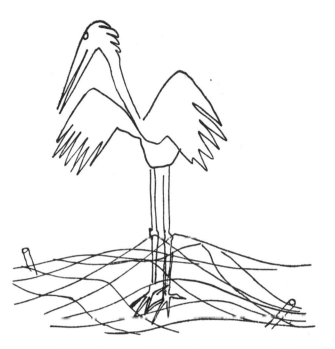

## A HUSBANDMAN AND A STORK

A POOR innocent stork had the ill hap to be taken in a net that was layd for geese and cranes. The storks plea for her self was simplicity, and piety : the love she bore to mankind, and the service she did in picking up of venomous creatures. This is all true, says the husbandman; but they that keep ill company, if they be catch'd with ill company, must expect to suffer with ill company.

### THE MORAL

*'Tis as much as a man's life, fortune, and reputation, are worth, to keep good company (over and above the contagion of lewd examples) for as Birds of a feather will flock together, so if the good and the bad be taken together, they must expect to go the way of all flesh together.*

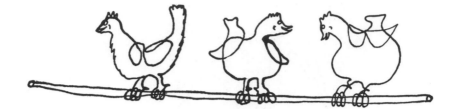

# A WOMAN AND A FAT HEN

A GOOD WOMAN had a hen that laid her every day an egg. Now she fancy'd to her selfe, that upon a larger allowance of corn, this hen might be brought in time to lay twice a day. She try'd the experiment; but the hen grew fat upon't, and gave quite over laying.

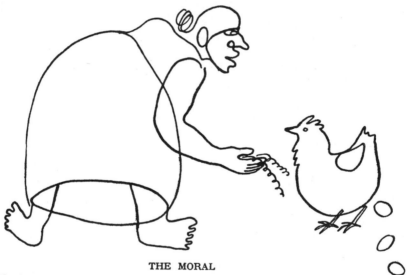

### THE MORAL

*He that has a great deal already, and would have more, will never think he has enough 'till he has all; and that's impossible : wherefore we should set bounds to our desires, and content our selves when we are well, for fear of losing what we had.*

# A DAW AND PIGEONS

A DAW took particular notice of the pigeons in such a certain dove-house, that they were very well fed, and provided for : so he went and painted himself of a dove colour, and took his commons with the pigeons. So long as he kept his own counsel, he pass'd for a bird of the same feather; but it was his hap once at unawares, to cry [Kaw,] upon which discovery, they beat him out of the house, and when he came to his old companions again, they'd have none of him neither; so that he lost himself both ways by this disguise.

### THE MORAL

*He that trims betwixt two interests, loses himself with both, when he comes to be detected, for being true to neither.*

# JUPITER AND FRAUD

JUPITER appointed Mercury to make him a composition of fraud and hypocrisie, and to give every artificer his dose on't. The medicine was prepar'd according to the bill, and the proportions duly observ'd, and divided : only there was a great deal too much of it made, and the overplus remain'd still in the morter. Upon examining the whole account, there was a mistake it seems, in the reck'ning; for the taylors were forgott'n in the catalogue : so that Mercury, for brevity sake, gave the taylors the whole quantity that was left; and from hence comes the old saying : There's knavery in all trades, but most in taylors.

### THE MORAL

*It is in some sort natural to be a knave. We were made so, in the very composition of our flesh and blood; only fraud is call'd wit in one case, good husbandry in another, &c., while 'tis the whole bus'ness of the world for one man to couzen another.*

## MERCURY AND TIRESIAS

MERCURY had a great mind to try if Tiresias was so famous a diviner as the world took him for, or not. So he went and stole Tiresias's oxen; and order'd the matter to be in the company with Tiresias, as upon bus'ness by the by, when the news should be brought him of the loss of his oxen. Mercury went to Tiresias in the shape of a man, and the tidings came as Mercury had contriv'd it : upon this, he took Mercury up to a high tower, hard by, and bad him look well about him, and tell him what birds he saw. Why, says Mercury, I see an eagle upon wing there, that takes her course from the right-hand to the left. That eagle (says Tiresias) is nothing to our purpose; wherefore pray look again once. Mercury stood gazing a while, and then told Tiresias of a crow he had discover'd upon a tree, that was one while looking up into the air, and another while down towards the ground : That's enough; (says Tiresias) for this motion of the crow, is as much as to say, I do appeal to heaven, and to earth, that the man that is now with Tiresias, can help him to his oxen again if he pleases.

### THE MORAL
*This fable is of a general application to all bold and crafty thieves and impostors. It serves also to set forth the vanity of wizzards, fortune-tellers, and the like.*

## A SOW AND A BITCH

A SOW and a bitch had a dispute once, which was the fruit-fuller of the two. The sow yielded it at last to the bitch; but you are to take notice at the same time, says she, that your puppies are all blind.

### THE MORAL
*The question among all sorts of competitors is not who does most, but who does best.*

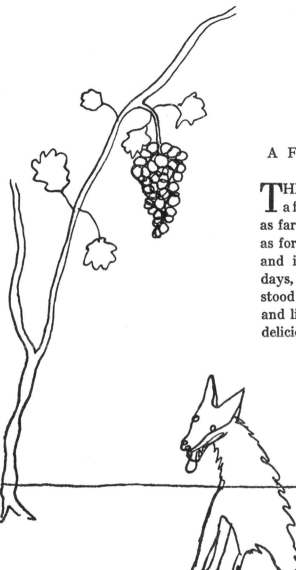

## A FOX AND GRAPES

THERE was a time, when a fox would have ventur'd as far for a bunch of grapes as for a shoulder of mutton, and it was a fox of those days, and of that palate, that stood gaping under a vine, and licking his lips at a most delicious cluster of grapes

that he had spy'd out there; he fetched a hundred and a hundred leaps at it, 'till at last, when he was as weary as a dog, and found that there was no good to be done; Hang 'em (says he) they are as sowr as crabs; and so away he went, turning off the disappointment with a jest.

## A WOLFE AND A LYON

A S a wolfe and a lyon were abroad upon adventure together, Heark, (says the wolfe) don't you hear the bleating of sheep? My life for yours sir, I'le go fetch ye a purchase. Away he goes,

and follows his eare, till he came just under the sheepfold : but it was so well fortify'd, and the dogs asleep so near it, that back he comes sneaking to the lyon again, and tells him, There are sheep

yonder (says he) 'tis true, but they are as lean as carrion, and we had e'en as good let 'em alone 'till they have more flesh on their backs.

THE MORAL OF THE TWO FABLES ABOVE

*'Tis matter of skill and address, when a man cannot honestly compass what he would be at, to appear easy and indifferent upon all repulses and disappointments.*

## THE BELLY AND MEMBERS

THE commoners of Rome were gon off once into a direct faction against the Senate. They'd pay no taxes, nor be forc'd to bear arms, they said, and 'twas against the liberty of the subject to pretend to compel them to't. The sedition, in short, ran so high, that there was no hope of reclaiming them, till Menenius Agrippa brought them to their wits again by this apologue :

The hands and the feet were in a desperate mutiny once against the belly. They knew no reason, they said, why the one should lye lazying, and pampering it self with the fruit of the others labour; and if the body would not work for company, they'd be no longer at the charge of maintaining it. Upon this mutiny, they kept the body so long without nourishment, that all the parts suffer'd for't : insomuch that the hands and feet came in the conclusion to find their mistake, and would have been willing then to have done their office; but it was now too late, for the body was so pin'd with over-fasting, that it was wholly out of condition to receive the benefit of a relief : which gave them to understand, that body and members are to live and die together.

THE MORAL

*The publick is but one body, and the prince the head on't; so that what member soever withdraws his service from the head, is no better than a negative traitor to his country.*

21

# A LYON, FOX, AND A WOLFE

THE king of beasts was now grown old, and sickly, and all his subjects of the forrest, (saving only the fox) were to pay their duties to him. The wolfe, and the fox like a couple of sly knaves, were still putting tricks one upon another, and the wolfe took this occasion to do the fox a good office. I can assure your majesty, says the wolfe, that 'tis nothing but pride and insolence that keeps the fox from shewing himself at court as well as his companions. Now the fox had the good luck to be within hearing, and so presented himself before the lyon, and finding him extremely enrag'd, begs his majesties patience, and a little time only for his defence. Sir (says he) I must presume to value my self upon my respect and loyalty to your majesty, equal at least to any of your other subjects; and I will be bold to say, that put them all together, they have not taken half the pains for your majesties service now upon this very occasion, that I have done. I have been hunting up and down far and near, since your unhappy indisposition, to find out a remedy for ye, which with much ado I have now compass'd at last, and it is that which I promise my self will prove an infallible cure. Tell me immediately (says the lyon) what it is then: Nothing in the world, says the fox, but to flay a wolfe alive, and wrap your body up in the warm skin. The wolfe was by all this while; and the fox in a snearing way advis'd him for the future, not to irritate a prince against his subjects, but rather to sweeten him with peaceable, and healing councells.

### THE MORAL

*The bus ness of a pickthank is the basest of offices, but yet diverting enough some-times, when one rascal happens to be encounter'd with another.*

## A LYONESS AND A FOX

A NUMEROUS issue passes in the world for a blessing; and this consideration made a fox cast it in the teeth of a lyoness, that she brought forth but one whelp at a time. Very right, says the other, but then that one is a lyon.

### THE MORAL

*'Tis a common thing to value things more by the number, then by the excellency of them.*

## TWO YOUNG MEN AND A COOK

TWO young fellows slipt into a cooks shop, and while the master was busie at his work, one of them stole a piece of flesh, and convey'd it to the other. The master missed it immediately, and challeng'd them with the theft. He that took it, swore he had none on't. And he that had it, swore as desperately that he did not take it. The cook reflecting upon the conceit :

23

Well, my masters, (says he) these frauds and fallacies may pass upon men; but there's an eye above that sees thorough them.

*There's no putting of tricks upon an all-seeing power; as if he that made our hearts, and knows every nook, and corner of them, could not see thorough the childish fallacy of a double-meaning.*

## A WOLF AND A SOW

A WOLF came to a sow that was just lying down, and very kindly offer'd to take care of her litter. The sow as civily thank'd her for her love, and desir'd she would be pleas'd to stand off a little, and do her the good office at a distance.

THE MORAL
*There are no snares so dangerous as those that are laid for us under the name of good offices.*

24

## THE WASHING OF A BLACKMORE

A MAN gave mony for a black, upon an opinion that his swarthy colour was rather flattery then nature; and the fault of his last master, in a great measure, that he kept him no cleaner : he took him home with him, and try'd all manner of washes to bring him to a better complexion : but there was no good to be done upon him; beside, that the very tampering cast him into a disease.

## A RAVEN AND A SWAN

A RAVEN had a great mind to be as white as a swan, and fancy'd to himself that the swan's beauty proceeded in a high degree, from his often washing and dyet. The raven upon this quitted his former course of life and food, and betook himself to the lakes and the rivers : but as the water did him no good at all for his complexion, so the experiment cost him his life too for want of sustenance.

### THE MORAL OF THE TWO FABLES ABOVE

*Natural inclinations may be moulded and wrought upon by good councell and discipline; but there are certain specifick properties and impressions, that are never to be alter'd or defac'd.*

## A CROW AND A DOG

A CROW invited a dog to joyn in a sacrifice to Minerva. That will be to no purpose (says the dog) for the goddess has such an aversion to ye, that you are particularly excluded out of all auguries. Ay, says the crow, but I'll sacrifice the rather to her for that, to try if I can make her my friend.

### THE MORAL

*We find it in the practice of the world, that men take up religion more for fear, reputation, and interest, then for true affection.*

25

## MERCURY AND A STATUARY

MERCURY had a great mind once to learn what credit he had in the world, and he knew no better way, then to put on the shape of a man, and take occasion to discourse the matter, as by the by, with a statuary : so away he went to the house of a great master, where, among other curious figures, he saw several excellent pieces of the gods. The first he cheapen'd was a Jupiter, which would have come at a very easy rate. Well (says Mercury) and what's the price of that Juno there? The carver set that a little higher. The next figure was a Mercury, with his rod and his wings, and all the ensigns of his commission. Why, this is as it should be, says he, to himself : for here am I in the quality of Jupiter's messenger, and the patron of artizans, with all my trade about me : and now will this fellow ask me fifteen times as much for this as he did for t'other : and so he put it to him, what he valu'd that piece at : why truly, says the statuary, you seem to be a civil gentleman, give me but my price for the other two, and you shall e'en have that into the bargain.

### THE MORAL
*This is to put the vanity of those men out of countenance, that by setting too high a value upon themselves, appear by so much the more despicable to others.*

## A STAG AND A LYON

A STAG that was close pursu'd by huntsmen, fled for safety into a lyons den; and as he was just expiring under the paw of the lyon : Miserable creature that I am, says he, to fly for protection from men, to the most unmerciful of beasts!

### THE MORAL
*There are harder and gentler wayes, even of ruine it selfe; as 'tis common we see for men under a capital sentence to petition even for the change of the death.*

26

## A COUNTRYMAN AND A SNAKE

THERE was a snake that bedded himself under the threshold of a country-house : a child of the family happen'd to set his foot upon't; the snake bit him, and he di'd on't. The father of the child made a blow at the snake, but miss'd his aim, and only left a mark behind him upon the stone where he struck. The countryman offered the snake, some time after this, to be friends again. No, says the snake, so long as you have this flaw upon

27

the stone in your eye, and the death of the child in your thought, there's no trusting of ye.

### THE MORAL

*In matter of friendship and trust, we can never be too tender; but yet there's a great difference betwixt charity and facility. We may hope well in many cases, but let it be without venturing neck, and all upon't, for* new converts are slippery.

## A FOX AND A STORK

THERE was a great friendship once betwixt a fox and a stork, and the former would needs invite the other to a treat. They had several soups serv'd up in broad dishes and plates, and so the fox fell to lapping, himself, and bad his guest heartily welcom to what was before him. The stork found he was put upon, but set so good a face however upon his entertainment; that his friend by all means must take a supper with him that night in revenge. The fox made several excuses upon the matter of trouble and expence, but the stork, in fine, would not be said nay; so that at last, he promised him to come. The collation was serv'd up in glasses, with long narrow necks, and the best of every thing that was to be had. Come (says the stork to his friend) pray be as free as if you were at home, and so fell to't very savourly himself. The fox quickly found this to be a trick, though he could not but allow of the contrivance as well as the justice of the revenge. For such a glass of sweet-meats to the one, was just as much to the purpose, as a plate of porridge to the other.

### THE MORAL

*'Tis allowable in all the liberties of conversation to give a man* a Rowland for his Oliver, *and to* pay him in his own coin, *as we say; provided always that we keep within the compass of honour, and good manners.*

28

## A FROG AND A MOUSE

THERE fell out a bloody quarrel once betwixt the frogs and the mice about the sovereignty of the fenns; and whilst two of their champions were disputing it at swords point, down comes a kite powdering upon them in the interim, and gobbles up both together, to part the fray.

## A LION AND A BEAR

THERE was a lion and a bear had gotten a fawn betwixt them, and there were they at it tooth and nail, which of the two should carry't off. They fought it out, till they were e'en glad to lie down, and take breath. In which instant, a fox passing that way, and finding how the case stood with the two combatants, seiz'd upon the fawn for his own use, and so very fairly scamper'd away with him. The lion and the bear saw the whole action, but not being in condition to rise and hinder it, they pass'd this reflexion upon the whole matter; here have we been worrying one another, who should have the booty, 'till this cursed fox has bobb'd us both on't.

### THE MORAL OF THE TWO FABLES ABOVE

'Tis the fate of all Gotham-quarrels, when fools go together by the ears, to have knaves run away with the stakes.

29

## A DOG AND A COCK UPON A JOURNY

A DOG and a cock took a journy together. The dog kennell'd in the body of a hollow tree, and the cock roosted at night upon the boughs. The cock crow'd about midnight; (at his usual hour) which brought a fox that was abroad upon the hunt, immediately to the tree; and there he stood licking of his lips, at the cock, and wheedling him to get him down. He protested he never heard so angelical a voice since he was born, and what would not he do now, to hugg the creature that had given him so admirable a serenade! Pray, says the cock, speak to the porter below to open the door, and I'll come down to ye : the fox did as he was directed, and the dog presently seiz'd and worry'd him.

THE MORAL

*The main bus'ness of the world is nothing but sharping, and putting tricks upon one another by turns.*

## AN AXE AND A FORREST

A CARPENTER that had got the iron-work of an axe allready, went to the next forrest to beg only so much wood as would make a handle to't. The matter seem'd so small that the request was easily granted; but when the timber-trees came to find that the whole wood was to be cut down by the help of this handle, There's no remedy, they cry'd, but patience, when people are undone by their own folly.

## A TREE AND A WEDGE

A WORKMAN was cutting down a tree to make wedges of it. Well! says the tree, I cannot but be extremely troubled at the thought of what I'm now a doing; and I do not so much complain neither, of the axe that does the execution, as of the

30

man that guides it; but it is my misery that I am to be destroy'd by the fruit of my own body.

## THE EAGLE AND ARROW

AN eagle that was watching upon a rock once for a hare, had the ill hap to be struck with an arrow. This arrow, it seems, was feather'd from her own wing, which very consideration went nearer her heart, she said, than death it self.

## A THRUSH TAKEN WITH BIRDLIME

IT was the fortune of a poor thrush, among other birds, to be taken with a bush of lime twigs, and the miserable creature reflecting upon it, that the chief ingredient in the birdlime came out of her own guts : I am not half so much troubled, says the thrush, at the thought of dying, as at the fatality of contributing to my own ruine.

### THE MORAL OF THE FOUR FABLES ABOVE

*Nothing goes nearer a man in his misfortunes, then to find himself undone by his own folly, or but any way accessory to his own ruine.*

## A WOMAN AND HER TWO DAUGHTERS

A WOMAN that had two daughters, bury'd one of them, and mourners were provided to attend the funeral. The surviving daughter wonder'd to see strangers so much concern'd at the loss of her sister, and her nearest relations so little. Pray mother, says she, what's the reason of this? Oh, says the mother, we that are a-kin to her, are never the better for crying, but the strangers have money for't.

### THE MORAL

*Mourners are as mercenary as common prostitutes; they are at his service that bids most for them.*

## A CAT AND VENUS

A YOUNG fellow that was passionately in love with a cat, made it his humble suit to Venus to turn puss into a woman. The transformation was wrought in the twinkling of an eye, and out she comes, a very bucksome lass. The doting sot took her home to his bed; and bad fair for a litter of kittens by her that night : but as the loving couple lay snugging together, a toy took Venus in the head, to try if the cat had chang'd her manners with her shape; and so for experiment,

turn'd a mouse loose into the chamber. The cat, upon this temptation, started out of the bed, and without any regard to the marriage-joys, made a leap at the mouse, which Venus took for so high an affront, that she turned the madam into a puss again.

<div align="center">THE MORAL</div>

*The extravagant transports of love, and the wonderful force of nature, are unaccountable; the one carries us out of our selves, and the other brings us back again.*

## AN ASSE AND AN UNGRATEFUL MASTER

A POOR asse, that what with age, labour, and hard burdens, was now worn out to the stumps in the service of an unmerciful master, had the ill hap one day to make a false step, and to fall down under his load. His driver runs up to him immediately, and beats him almost to death for't. This (says the asse to himself) is according to the course of the ungrateful world. One casual slip is enough to weigh down the faithful and affectionate services of long life.

## AN OLD DOG AND HIS MASTER

A N old dog, that in his youth had led his master many a merry chase, and done him all the offices of a trusty servant, came at last, upon falling from his speed and vigour, to be loaden at every turn with blows and reproaches for it. Why sir, (says the dog) my will is as good as ever it was; but my strength, and my teeth are gone; and you might with as good a grace, and every jot as much justice, hang me up because I'm old, as beat me because I'm impotent.

<div align="center">THE MORAL OF THE TWO FABLES ABOVE</div>

*The reward of affection and fidelity must be the work of another world : not but that the conscience of well-doing is a comfort that may pass for a recompence even in this; in despite of ingratitude and injustice.*

# A DOG INVITED TO SUPPER

A GENTLEMAN invited a friend to supper with him, and the gentleman's dog was so well bred as to invite the friend's dog to come for company. The dog came at his hour, and into the kitchin he went, to see what good cheer was toward: but as he was there, wagging his tayle, and licking his lips, at the thought of what a meale he was like to make on't, the roguy cook got slyly behind him, and spoil'd the jest. He took him up by the tayle at unawares, and after a turn or two in the air, flung him out of the window. So soon as ever the poor devil had recover'd the squelch, away he scampers, bawling like mad, with I know not how many prick-ear'd currs at the heels of him, to know how he lik'd his wellcome. Why truly, says he, they have given me as much drink, as my skin will hold; and it has made me so light-headed, I could not find the right way out of the house again.

### THE MORAL

Love me, love my dog, *says the old proverb, and there's somewhat of good manners, as well as of good nature in't; for there are certain decencies of respect due to the servant for the master's sake.*

# THE FROGS CHUSE A KING

IN the days of old, when the frogs were all at liberty in the lakes, and grown quite weary of living without government, they petition'd Jupiter for a king, to the end that there might be some distinction of good and evil, by certain equitable rules and methods of reward and punishment. Jupiter, that knew the vanity of their hearts, threw them down a log for their governour; which upon the first dash, frighted the whole mobile of them into the mudd for the very fear on't. This panick terror

34

kept them in awe for a while, 'till in good time, one frog, bolder than the rest, put up his head, and look'd about him, to see how squares went with their new king. Upon this, he calls his fellow-subjects together; opens the truth of the case; and nothing would serve them then, but riding a-top of him, insomuch that the dread they were in before, is now turned into insolence, and tumult. This king they said was too tame for them, and Jupiter must needs be entreated to send 'em another : he did so, but authors are divided upon it, whether 'twas a stork, or a serpent; though whether of the two soever it was, he left them neither liberty, nor property, but made a prey of his subjects. Such was their condition in fine, that they sent Mercury to Jupiter yet once again for another king, whose answer was this : They that will not be contented when they are well, must be patient when things are amiss with them; and people had better rest where they are, than go farther, and fare worse.

### THE MORAL

*The* mobile *are uneasie without a ruler : they are as restless with one; and the oft'ner they shift, the worse they are; so that government or no government; a king of God's making, or of the peoples, or none at all; the multitude are never to be satisfied.*

## A RAVEN AND A SNAKE

AS a snake lay lazing at his length, in the gleam of the sun, a raven took him up, and flew away with him. The snake kept a twisting and turning, till he bit the raven, and made him curse himself for being such a fool, as to meddle with a purchace that had cost him his life.

### THE MORAL

*Nature has made all the necessaries of life, safe and easie to us, but if we will be hankering after things that we neither want nor understand, we must take our fortune, even if death it self should happen to be in the case.*

**35**

## A THUNNY AND A DOLPHIN

A THUNNY gave chace to a dolphin; and when he was just ready to seize him, the thunny struck before he was aware, and the dolphin, in the eagerness of his pursuit, ran himself a ground with him. They were both lost; but the thunny kept his eye still upon the dolphin, and observing him when he was just at last gasp : Well, says he, the thought of death is now easy to me, so long as I see my enemy go for company.

## TWO ENEMIES AT SEA

THERE were two enemies at sea in the same vessel, the one at the ships head, the other at the stern. It blew a dreadful storm, and when the vessel was just ready to be swallow'd up, one of 'em ask'd the master, which part of the ship would be first under water; so he told him the t'other end would sink first. Why then, says he, I shall have the comfort of seeing my enemy go before me.

### THE MORAL OF THE TWO FABLES ABOVE

*'Tis a wretched satisfaction, that a revengeful man takes, even in the losing of his own life, provided that his enemy may go for company.*

## HARES, FOXES, AND EAGLES

THERE goes an old story of a bloudy war betwixt the hares, and the eagles; and the hares would fain have drawn the foxes into their alliance, but very franckly and civilly, they gave them this answer. That they would serve them with all their hearts, if they did not perfectly understand both the hares themselves, and the enemy they were to cope withal.

### THE MORAL

*There's no ent'ring into any league, without well examining the faith, and strength of the parties to't.*

36

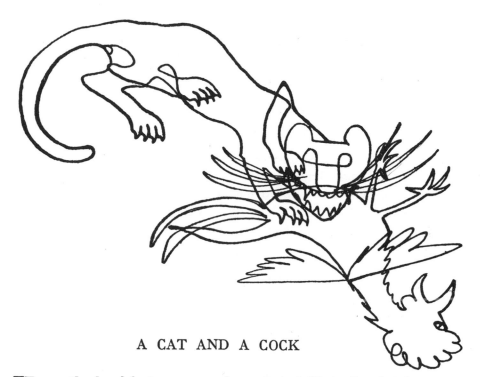

## A CAT AND A COCK

IT was the hard fortune once of a cock, to fall into the clutches of a cat. Puss had a months mind to be upon the bones of him, but was not willing to pick a quarrel however, without some plausible color for't. Sirrah (says she) what do you keep such a bawling, and screaming a nights for, that no body can sleep near you? Alas, says the cock, I never wake any body, but when 'tis time for people to rise, and go about their business. Nay, says the cat, and then there never was such an incestuous rascal : why, you make no more conscience of lying with your own mother, and your sisters — In truth, says the cock again, that's only to provide eggs for my master and mistress. Come,

37

come, says puss, without any more ado, 'tis time for me to go to breakfast, and cats don't live upon dialogues; at which word she gave him a pinch, and so made an end, both of the cock, and of the story.

## A WOLF AND A LAMB

AS a wolf was lapping at the head of a fountain, he spy'd a lamb, paddling at the same time, a good way off down the stream. The wolf had no sooner the prey in his eye, but away he runs open-mouth to't. Villain (says he), how dare you lye muddling the water that I'm a drinking? Indeed, says the poor lamb, I did not think that my drinking there below, could have foul'd your water so far above. Nay, says t'other, you'll never leave your chopping of logick till your skin's turn'd over your ears, as your fathers was, a matter of six months ago, for prating at this sawcy rate; you remember it full well, sirrah. If you'll believe me, sir, (quoth the innocent lamb, with fear and trembling) I was not come into the world then. Why thou impudence, cries the wolf, hast thou neither shame, nor conscience? But it runs in the blood of your whole race, sirrah, to hate our family; and therefore since fortune has brought us together so conveniently, you shall e'en pay some of your fore-fathers scores before you and I part; and so without any more ado, he leapt at the throat of the miserable helpless lamb, and tore him immediately to pieces.

### THE MORAL OF THE TWO FABLES ABOVE

'Tis an easie matter to find a staff to beat a dog. *Innocence is no protection against the arbitrary cruelty of a tyrannical power: but reason and conscience are yet so sacred, that the greatest villanies are still countenanc'd under that cloak and color.*

## A CITY MOUSE AND A COUNTRY MOUSE

THERE goes an old story of a country mouse that invited a
city-sister of hers to a country collation, where she spar'd for
nothing that the place afforded; as mouldy crusts, cheese parings,
musty oatmeal, rusty bacon, and the like. Now the city-dame
was so well bred, as seemingly to take all in good part : but yet
at last, Sister (says she, after the civilest fashion) why will you

**39**

be miserable when you may be happy? Why will you lie pining, and pinching your self in such a lonesome starving course of life as this is; when 'tis but going to town along with me; to enjoy all the pleasures, and plenty that your heart can wish? This was a temptation the country mouse was not able to resist; so that away they trudg'd together, and about midnight got to their journeys end. The city mouse shew'd her friend the larder, the pantry, the kitchin, and other offices where she laid her stores; and after this, carry'd her into the parlour, where they found, yet upon the table, the reliques of a mighty entertainment of that very night. The city-mouse carv'd her companion of what she lik'd best, and so to't they fell upon a velvet couch together : The poor bumkin that had never seen, nor heard of such doings before, bless'd her self at the change of her condition, when (as ill luck would have it) all on a sudden, the doors flew open, and in comes a crowd of roaring bullies, with their wenches, their dogs, and their bottles, and put the poor mice to their wits end, how to save their skins. The stranger especially, that had never been at this sport before; but she made a shift however for the present, to slink into a corner, where she lay trembling and panting 'till the company went their way. So soon as ever the house was quiet again, Well : my court sister, says she, if this be the way of your town-gamboles, I'll e'en back to my cottage, and my mouldy cheese again; for I had much rather lie knabbing of crusts, without either fear or danger, in my own little hole, than be mistress of the whole world with perpetual cares and alarums.

THE MORAL

*The difference betwixt a court and a country life. The delights, innocence, and security of the one, compar'd with the anxiety, the lewdness, and the hazards of the other.*

**40**

## A YOUNG MAN AND A SWALLOW

A PRODIGAL young fellow that had sold his cloths to his very shirt, upon the sight of a swallow that came abroad before her time, made account that summer was now at hand, and away went that too. There happen'd after this, a fit of bitter cold weather, that almost starv'd both the bird, and the spendthrift. Well (says the fellow to himself) this sot of a swallow has been the ruine of us both.

### THE MORAL

*Extraordinary cases are excepted out of the general rules of life : so that irregular accidents and instances are not to be drawn into precedent.*

# A LARK IN A NET

A POOR lark enter'd into a miserable expostulation with a bird-catcher, that had taken her in his net, and was just about to put her to death. Alas (says she) what am I to dye for now? I am no thief; I have stoln neither gold, nor silver; but for making bold with one pityful grain of corn am I now to suffer.

### THE MORAL
*'Tis to no purpose to stand reasoning where the adversary is both party andjudge.*

# A FOX AND HUNTSMEN

A FOX that had been hard-run, begg'd of a countryman that he saw at work in a wood, to help him to some hiding-place. The man directed him to his cottage, and thither he went. He was no sooner got in, but the huntsmen were presently at the heels of him, and asked the cottager if he did not see a fox that way? No truly, says he, I saw none; but pointed at the same time with his finger to the place where he lay. The huntsmen did not take the hint, but the fox spy'd him, it seems, through a peeping hole he had found out to see what news : so the fox-hunters went their way, and then out steals the fox, without one word speaking. Why how now, says the man, han't ye the manners to take leave of your host before you go? Yes, yes, says the fox; if you had been as honest of your fingers, as you were of your tongue, I should not have gone without bidding ye farewell.

### THE MORAL
*A man may tell a lye by signs, as well as in words at length, and his conscience is as answerable for his fingers, as for his tongue.*

## TWO TRAVELLERS AND A BAG OF MONEY

AS two travellers were upon the way together, one of 'em stoops, and takes up something. Look ye here (says he) I have found a bag of money. No, says t'other, when two friends are together, you must not say [I] have found it, but [we] have found it. The word was no sooner. out, but immediately comes a hue and cry after a gang of thieves that had taken a purse upon the road. Lord! brother (says he that had the bag) we shall be utterly undone. Oh phy, says t'other, you must not say [we] shall be undone, but [I] shall be undone; for if I'm to have no part in the finding, you must not think I'll go halves in the hanging.

### THE MORAL
*They that will enter into leagues and partnerships, must take the good and the bad one with another.*

## A WIFE AND A DRUNKEN HUSBAND

A WOMAN that lay under the mortification of a fuddling husband, took him once when he was dead drunk; and had his body layd in a charnel-house. By the time that she thought he might be come to himself again, away goes she, and knocks at the door. Who's there (says the toper). One, says the woman, that brings meat for the dead. Friend, says he, bring me drink rather. I wonder any body that knows me, should bring me one without t'other. Nay then, says she, the humour I perceive has taken possession of him; he has gotten a habit, and his case is desperate.

### THE MORAL
*Inveterate ill habits become another nature to us, and we may almost as well be taken to pieces, and new put together again, as mended.*

## A PIGEON AND A CROW

A PIGEON that was brought up in a dove-house, was bragging to a crow how fruitful she was. Never value your self says the crow upon that vanity; for the more children, the more sorrow.

THE MORAL

*Many children are a great blessing; but a few good ones are a greater; all hazzards consider'd.*

## AN ASSE AND A WHELP

A GENTLEMAN had got a favourite spaniel, that would be still toying, and leaping upon him, licking his cheeks, and playing a thousand pretty gambles, which the master was well enough pleas'd withall. This wanton humour succeeded so well with the puppy, that an asse in the house would needs go the same gamesom way to work, to curry favour for himself too; but he was quickly given to understand, with a good cudgel, the difference betwixt the one play-fellow and the other.

THE MORAL

*People that live by example, should do well to look very narrowly into the force and authority of the president, without saying, or doing things at a venture : for that may become one man, which would be absolutely intolerable in another, under differing circumstances.*

44

## A BOY AND A SNAKE

A BOY was groping for eles, and layd his hand upon a snake, but the snake, finding it was pure simplicity, and not malice, admonish'd him of his mistake; keep your self well while you are well, says the snake; for if you meddle with me, you'll repent your bargain.

### THE MORAL
*'Tis the intention, morally speaking, that makes the action good or bad; and even brutes themselves will put a difference betwixt harms of ill-will and mischance.*

## A COLLYER AND A FULLER

A FULLER had a very kind invitation from a collyer to come and live in the house with him. He gave him a thousand thanks for his civility; but told him that it would not stand with his convenience; for (says he) as fast as I make any thing clean, you'll be smutting it again.

## A THRUSH AND A SWALLOW

AH my dear mother! says the thrush, never had any creature such a friend as I have, of this same swallow. No, says she, nor ever any mother such a fool to her son as I have, of this same thrush; to talk of a friendship betwixt people that cannot so much as live together in the same climate and season. One is for the summer, t'other for winter; and that which keeps you alive, kills your companion.

### THE MORAL OF THE TWO FABLES ABOVE
*'Tis a necessary rule in allyances, matches, societies, fraternities, friendships, partnerships, commerce, and all manner of civil dealings and contracts, to have a strict regard to the humour, the nature, and the disposition of those we have to do withall.*

## A CAMEL AT FIRST SIGHT

UPON the first sight of a camel, all people ran away from't, in amazement at so monstrous a bulk. Upon the second sight, finding that it did them no hurt, they took heart upon't, went up to't, and view'd it. But when they came, upon further experience, to take notice, how stupid a beast it was, they ty'd it up, bridled it, loaded it with packs and burdens; set boys upon the back on't, and treated it with the last degree of contempt.

## A FOX AND A LYON

A FOX had the hap to fall into the walk of a lyon; (the first of the kind that ever he saw) and he was ready to drop down at the very sight of him. He came a while after, to see another, and was frighted still; but nothing to what he was before. It was his chance, after this, to meet a third lyon; and he had the courage, then, to accost him, and to make a kind of an acquaintance with him.

### THE MORAL OF THE TWO FABLES ABOVE

*Novelty surprizes us, and we have naturally a horror for uncouth misshapen monsters; but 'tis our ignorance that staggers us, for upon custom and experience, all these buggs grow familiar, and easy to us.*

## AN UNHAPPY MATCH

THERE was a man, a long time ago, that had got a shrew to his wife, and there could be no quiet in the house for her. The husband was willing however to make the best of a bad game, and so for experiment sake, he sent her away for a while to her fathers. When he came a little after to take her home again, Prethee sweet-heart (says he) how go matters in the house where thou hast been? Introth, says she, they go I know not how : but there's none of the family, you must know, can endure me : no not so much as the very hinds and plough-men; I could read it in the faces of them. Ah wife! says the husband, if people that rise early and come home late, and are all day out of your sight, cannot be quiet for ye, what a case is your poor husband in, that must spend his whole life in your company.

### THE MORAL

*When man and wife cannot agree, prudence will oblige the one, and modesty the other, to put all their little controversies into their pockets, and make the best of a bad game.*

## A MOLE AND HER DAM

MOTHER (says a mole to her damm) here's a strange smell methinks. And then she was at it again, There's a mulberry-tree, I perceive. And so a third time, What a clattering of hammers do I hear. Daughter says the old one, you have now quite betray'd your self; for I thought you had wanted only one sense, and now I find you want three; for you can neither hear nor smell any more then you can see.

### THE MORAL
*Men labour under many imperfections that no body would take notice of, if they themselves were not over-sollicitous to conceal them.*

## A WOLFE AND A FOX

A WOLFE that had a mind to take his ease, stor'd himself privately with provisions, and so kept close a while. Why, how now friend says a fox to him, we han't seen you abroad at the chace this many a day! Why truly says the wolfe, I have gotten an indisposition that keeps me much at home, and I hope I shall have your prayers for my recovery. The fox had a fetch in't, and when he saw it would not fadge; away goes he presently to a shepherd, and tells him where he might surprize a wolfe if he had a mind to't. The shepherd follow'd his directions, and destroy'd him. The fox immediately, as his next heir, repairs to his cell, and takes possession of his stores; but he had little joy of the purchase, for in a very short time, the same shepherd did as much for the fox, as he had done before for the wolfe.

### THE MORAL
*'Tis with sharpers as 'tis with pikes, they prey upon their own kind : and 'tis a pleasant scene enough, when thieves fall out among themselves, to see the cutting of one diamond with another.*

## A SHEPHERD TURN'D MERCHANT

A COUNTRYMAN was feeding his flock by the seaside, and it was so delicate a fine day, that the smoothness of the water tempted him to leave his shepherds business, and set up for a merchant. So that in all hast, he puts off his stock; buys a bargain of figs; gets his freight abord, and away presently to sea. It happened to be very foul weather : so that the mariners were fain to cast their whole lading over-bord, to save themselves and the vessel. Upon this miscarriage, our new merchant-adventurer betook himself to his old trade again; and it happen'd one day, as he was tending his sheep upon the very same coast, to be just such a flattering tempting sea again, as that which had betray'd

him before. Yes, yes, says he, when the devil's blind! You'd ha' some more figs, with a vengeance, wou'd ye?

*Men may be happy in all estates if they will but suit their minds to their condition. A shepherd may be as easy in a cottage, as a prince in a palace, with a mind suited to his station; but if they will be launching out into trade, or bus'ness that they do not understand, they have nothing left them to trust to when they are once bewilder'd but the hope of some kind providence to put them in the right way home again.*

## AN EAGLE AND A FOX

THERE was a bargain struck up betwixt an eagle and a fox, to be wonderful good neighbours and friends. The one took-up in a thicket of brushwood, and the other timber'd upon a tree hard by. The eagle, one day when the fox was abroad a forraging, fell into his quarters and carry'd away a whole litter of cubbs at a swoop. The fox came time enough back to see the eagle upon wing, with her prey in the foot, and to send many a heavy curse after her; but there was no overtaking her. It happen'd in a very short time after this, upon the sacrificing of a goat, that the same eagle made a stoop at a piece of flesh upon the altar, and she took it away to her young : but some live coales it seems, that stuck to't, set the nest a fire. The birds were not as yet fledge enough to shift for themselves, but upon sprawling and struggling to get clear of the flame, down they tumbled, half roasted, into the very mouth of the fox, that stood gaping under the tree to see the end on't : So that the fox had the satisfaction, at last, of devouring the children of her enemy in the very sight of the damm.

*God reserves to himself the punishment of faithless, and oppressing governours, and the vindication of his own worship and altars.*

## A GOAT AND A VINE

A GOAT that was hard press'd by the huntsmen, took sanctuary in a vineyard, and there he lay close, under the covert of a vine. So soon as he thought the danger was over, he fell presently to browzing upon the leaves; and whether it was the rustling, or the motion of the boughs, that gave the huntsmen an occasion for a stricter search, is uncertain : but a search there was, and in the end discover'd the goat, and shot him. He dy'd in fine, with this conviction upon him, that his punishment was just, for offering violence to his protector.

### THE MORAL
*Ingratitude perverts all the measures of religion and society, by making it dangerous to be charitable and good natur'd.*

## A FAWN AND A STAG

A FAWN was reasoning the matter with a stag, why he should run away from the dogs still; for, says he, you are bigger and stronger then they. If you have a mind to stand, y'are better arm'd; and then y'are fleeter if you'll run for't. I can't imagine what should make you so fearful of a company of pityful currs. Nay, says the stag, 'tis all true that you say, and 'tis no more then I say to my self many times, and yet whatever the matter is, let me take up what resolutions I please, when I hear the hounds once, I cannot but betake my self to my heels.

### THE MORAL
*'Tis one thing to know what we ought to do, and another thing to execute it; and to bring up our practice to our philosophy : he that is naturally a coward is not to be made valiant by councell.*

51

## MERCURY AND A CARPENTER

A CARPENTER dropt his axe into a river, and put up a prayer to Mercury to help him to't again. Mercury div'd for't, and brought him up a golden one : but that was not it the fellow said : and so he plung'd a second time, and fetch'd up another, of silver. He sayd that was not it neither. He try'd once again, and then up comes an axe with a wooden handle, which the carpenter, sayd was the very tool that he had lost. Well! (says Mercury) thou art so just a poor wretch, that I'le give thee all three now for thy honesty. This story was got into every bodies mouth, and the rumour being spread, it came into a knaves head to try the same experiment over again. And so away goes he and down he sits, sniv'ling and whelping upon the bank of a river, that he had dropt his axe into the water there. Mercury, that was at hand it seems, heard his lamentation, and dipping once again for his axe, as he had done for the other; up he brings him a golden axe, and asks the fellow if that were it. Yes, yes, says he, this is it. Oh thou impudent sot, cryes Mercury; to think of putting tricks upon him that sees through the very heart of thee.

THE MORAL

*The great searcher of our hearts is not to be impos'd upon, but he will take his own time either to reward or punish.*

## A SWALLOW AND A CROW

UPON a dispute betwixt a swallow and a crow, which was the greater beauty of the two : Yours, says the crow, is only a spring-beauty, but mine lasts all the year round.

THE MORAL

*Of two things equally good, that's the best that lasts longest.*

52

## A WILD ASS AND A TAME

AS a tame ass was airing himself in a pleasant meadow, with a coat and carcass in very good plight, up comes a wild one to him from the next wood, with this short greeting. Brother (says he) I envy your happiness; and so he left him. It was his hap some short time after this encounter, to see his tame brother groaning under a unmerciful pack, and a fellow at his heels goading him forward. He rounds him in the ear upon't, and whispers him, My friend (says he) your condition is not, I perceive, what I took it to be, for a body may buy gold too

dear : and I am not for purchasing good looks and provender at this rate.

THE MORAL

*Betwixt envy and ingratitude, we make our selves twice miserable; out of an opinion, first, that our neighbour has too much; and secondly, that we our selves have too little.*

## AN ANT AND A FLY

THERE happen'd a warm dispute betwixt an ant and a fly. Why, where's the honour, or the pleasure in the world, says the fly, that I have not my part in? Are not all temples and palaces open to me? Am not I the taster to gods and princes, in all their sacrifices and entertainments? Am I not serv'd in gold and silver? And is not my meat and drink still of the best? And all this, without either mony or pains. I trample upon crowns, and kiss what ladies lips I please. And what have you now to pretend to all this while? Why, says the ant, you value your self upon the access you have to the altars of the gods, the cabinets of princes, and to all publick feasts and collations : and what's all this but the access of an intruder, not of a guest. For people are so far from liking your company, that they kill ye as fast as they can catch ye. You're a plague to 'em wherever you come. Your very breath has maggots in't, and for the kisse you brag of, what is it but the perfume of the last dunghill you touch'd upon, once remov'd? For my part I live upon what's my own, and work honestly in the summer to maintain my self in the winter; whereas the whole course of your scandalous life, is only cheating or sharping, one half of the year, and starving, the other.

THE MORAL

*Here's an emblem of industry, and luxury, set forth at large : with the sober advantages, and the scandalous excesses of the one and of the other.*

54

## A FLEA AND HERCULES

THERE was a fellow, that upon a flea-biting call'd out to Hercules for help. The flea gets away, and the man expostulates upon the matter. Well! Hercules; (says he) you that would not take my part against a sorry flea, will never stand by me in a time of need, against a more powerful enemy.

### THE MORAL
*We neglect God in greater matters, and petition him for trifles, nay and take pett at last if we cannot have our askings.*

## A LYON IN LOVE

A LYON fell in love with a country lass, and desir'd her father's consent to have her in marriage. The answer he gave was churlish enough. He'd never agree to't he say'd, upon any terms, to marry his daughter to a beast. The lyon gave him a sowr look upon't, which brought the bumkin, upon second thoughts, to strike up a bargain with him, upon these conditions; that his teeth should be drawn, and his nailes par'd; for those were things, he say'd, that the foolish girle was terribly afraid of. The lyon sends for a surgeon immediately to do the work; (as what will not love make a body do?). And so soon as ever the operation was over, he goes and challenges the father upon his promise. The countryman seeing the lyon disarm'd, pluck'd up a good heart, and with a swindging cudgel so order'd the matter, that he broke off the match.

### THE MORAL
*An extravagant love consults neither life, fortune, nor reputation, but sacrifices all that can be dear to a man of sense and honor, to the transports of an inconsiderate passion.*

55

## WASPS IN A HONEY–POT

THERE was a whole swarm of wasps got into a hony-pot, and there they cloy'd and clamm'd themselves, till there was no getting out again; which brought them to understand in the conclusion, that they had pay'd too deare for their sweet-meats.

THE MORAL

*Loose pleasures become necessary to us by the frequent use of them, and when they come once to be habitual, there's no getting clear again.*

## AN OLD MAN AND A LYON

A PERSON of quality dream't one night that he saw a lyon kill his only son : who was, it seems, a generous cavalier, and a great lover of the chace. This phansy ran in the father's head, to that degree, that he built his son a house of pleasure, on purpose to keep him out of harms way; and spar'd neither art nor cost to make it a delicious retreate. This house, in short, was to be the young man's prison, and the father made himself his keeper. There were a world of paintings every where up and down, and among the rest, there was the picture of a lyon; which stirred the bloud of the young man, for the dreame sake, and to think that he should now be a slave for the phansy of such a beast. In this indignation he made a blow at the picture; but striking his fist upon the point of a nayle in the wall, his hand cancerated; he fell into a fever, and soon after dy'd on't : so that all the father's precaution could not secure the son from the fatality of dying by a lyon.

THE MORAL

*A body may as well lay too little as too much stress upon a dreame; for some dreames are monitory, as others are only complexional: but upon the main, the less we heed them the better; for when that freake has once taken possession of a fantastical head, the distemper is incurable.*

56

## JUPITER
## AND A SERPENT

JUPITER had presents made him upon his wedding-day, greater, or less, from all living creatures. A serpent brought him a rose in his mouth for an offering. The thing was acceptable enough, but not the presenter; for (says Jupiter) though gifts are wellcome to me, of themselves, I must not yet receive any from a serpent.

### THE MORAL

*He that receives a present, contracts an obligation; which a body would be asham'd of in the case of an ill man; for it looks toward making a friendship with him.*

## AN APE AND A FOX

UPON the decease of a lyon of late famous memory, the beasts met in councel to chuse a king. There were several put up; but one was not of a make for a king, another wanted either brains, or strength, or stature, or humour, or something else; but in fine, the buffoon-ape with his grimaces and gamboles, carry'd it from the whole field by I know not how many voices. The fox (being one of the pretenders) stomach'd it extremely to see the choice go against him, and presently rounds the new-elect in the ear, with a piece of secret service that he could do him. Sir, says he, I have discover'd some hidden treasure yonder : but 'tis a royalty that belongs to your majesty, and I have nothing to do with it. So he carry'd the ape to take possession : and what should this treasure be, but a bayte in a ditch. The ape lays his hand upon't, and the trap springs and catches him by the fingers. Ah thou perfidious wretch, cryes the ape! Or thou simple prince, rather, replyes the fox. You a governour of others, with a vengeance, that han't wit enough to look to your own fingers.

### THE MORAL

*Governors should be men of business rather then pleasure. There's one great folly in making an ill choice of a ruler, and another in the acceptance of it; for it exposes authority to scorn.*

## A DOCTOR AND PATIENT WITH SORE EYES

A PHYSICIAN undertakes a woman with sore eyes, upon the terms of no cure no mony. His way was to dawb 'em quite up with oyntments, and while she was in that pickle, to carry off a spoon or a porringer, or somewhat or other at the end of his visit. The womans eyes mended, and still as she came more and more to her self again, there was every day less and less left

in the house to be seen. The doctor came to her at last, and told her; Mistress, says he, I have discharg'd my part, your eyes are perfectly well again, and pray let me be payd now according to our agreement. Alas sir, says she, I'm a great deal worse then I was the first minute you undertook me; for I could see plate, hangings, paintings, and other goods of value about my house, 'till you had the ordering of me; but I am now brought to such a pass, that I can see nothing at all.

<div align="center">THE MORAL</div>

*There are few good offices done for other people, which the benefactor does not hope to be the better for himself.*

## A CAT AND MICE

THERE was a house mightily troubled with mice, and a notable cat there was, that time after time had pick'd up so many of 'em, that they agreed among themselves to keep above in the cieling; for they found that upon the plain floor there was no living for 'em. This spoil'd pusses sport, unless she could find a way to trepan them down again. So she leapt up to a pin that was driven into the wall, and there hung like a polcat in a warren, to amuse them. The mice took notice of it, and one wiser then the rest stretched out his neck to learn the truth of the matter, and so soon as ever he found how 'twas, Ah, says he, you may hang there 'till your heart akes; for if you were but a dish-clout, as you are a counterfeiting devil of a cat, here's not a creature will come near ye.

<div align="center">THE MORAL</div>

*Let no man lay himself at the mercy of a known enemy, under any shew, or pretence whatsoever; for he forfeits his discretion, even though he should happen to save his carcass, and his fortune.*

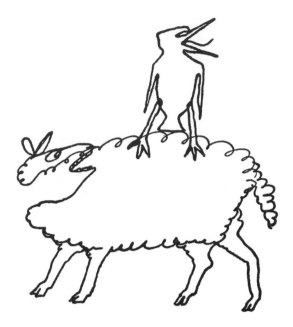

## A SHEEP AND A CROW

THERE was a crow sat chattering upon the back of a sheep; Well! sirrah, says the sheep, you durst not ha' done this to a dog. Why I know that says the crow as well as you can tell me, for I have the wit to consider whom I have to do withall. I can be as quiet as any body with those that are quarrelsome, and I can be as troublesome as another too, when I meet with those that will take it.

### THE MORAL

*'Tis the nature and the practice of drolls and buffoons, to be insolent toward those that will bear it, and as slavish to others that are more then their match.*

60

## A FOX AND A BRAMBLE

A FOX that was close pursu'd, took a hedge, the bushes gave way, and in catching hold of a bramble to break his fall, the prickles ran into his feet. Upon this, he layd himself down, and fell to licking his paws, with bitter exclamations against the bramble. Good words, Reynard, says the bramble, one would have thought you had known better things, then to expect a kindness from a common enemy, and to lay hold on that for relief, that catches at every thing else for mischiefe.

### THE MORAL
*There are some malicious natures that place all their delight in doing ill turns, and that man is hard put to't, that is first brought into a distress, and then forc'd to fly to such people for relief.*

## A DOG AND A WOLFE

A WOLFE took a dog napping at his master's door, and when he was just about to. worry him, the poor creature begg'd hard, only for a reprieve. Alas (says he) I'm as lean at present as carryon; but we have a wedding at our house within these two or three days, that will plump me up you shall see with good cheare. Pray have but patience 'till then, and when I'm in a little better case, I'll throw my self in the very mouth of ye. The wolfe tooke his word, and so let him go; but passing some few days after by the same house again, he spy'd the dog in the hall, and bad him remember his promise. Hear ye, my friend, says the dog; whenever you catch me asleep again, on the wrong side of the door, never trouble your head to wait for a wedding.

### THE MORAL
*Experience works upon many brutes more then upon some men. They are not to be gulled twice with the same trick; and at the worst, a bad shift is better than none.*

## FISHERMEN DISAPPOINTED

SOME fishermen that had been out a whole day with a drag-net, and caught nothing, had a draught toward the evening, that came home very heavy, which put 'em in hope of a sturgeon at least, but upon bringing the net ashore, it prov'd to be only one great stone, and a few little fishes. Upon this disappointment they were down in the mouth again; but says one of the company that was a little graver then the rest, you are to consider, my masters, that joy and sorrow are two sisters that follow one another by turns.

### THE MORAL
*All our purchases in this world are but the catching of a Tartar, as we say, but it is some comfort yet to consider, that when things are at the worst they'l mend.*

## A DOCTOR AND HIS PATIENT

PRAY sir how d'ye find your self? says the Dr. to his patient. Why truly, says the patient; I have had a violent sweat. Oh the best sign in the world quoth the Dr. And then a little while after he is at it again, with a Pray how d'ye find your body? Alas, says the t'other, I have just now such a terrible fit of horror and shaking upon me! Why this is all as it should be, says the physician, it shews a mighty strength of nature. And then he comes over him a third time with the same question again; why I am all swell'd says t'other, as if I had a dropsy; Best of all quoth the doctor, and goes his way. Soon after this comes one of the sick man's friends to him with the same question, how he felt himselfe; why truly so well, says he, that I'm e'en ready to dye, of I know not how many good signs and tokens.

### THE MORAL
*A death-bed flattery is the worst of treacheries.*

62

## THE KITE, HAWK, AND PIGEONS

THE pigeons finding themselves perse-
cuted by the kite, made choice of the
hawk for their guardian. The hawk sets up
for their protector; but under countenance
of that authority, makes more havock in
the dove-house in two days, than the kite
could have done in twice as many months.

### THE MORAL

*'Tis a dangerous thing for people to call in a powerful
and an ambitious man for their protector; and upon the
clamour of here and there a private person, to hazard
the whole community.*

63

## A BAT, BRAMBLE AND CORMORANT

A BAT, a bramble, and a cormorant enter'd into covenants with articles, to joyn stocks, and trade in partnership together. The bat's adventure was ready mony that he took up at interest; the bramble's was in cloaths; and the cormorant's in brass. They put to sea, and it so fell out, that ship and goods were both lost by stress of weather: but the three merchants by providence got safe to land. Since the time of this miscarriage, the bat never stirrs abroad till night, for fear of his creditors. The bramble lays hold of all the cloaths he can come at in hope to light upon his own again : and the cormorant is still sauntering by the sea-side, to see if he can find any of his brass cast up.

THE MORAL

*The impression of any notable misfortune will commonly stick by a man as long as he lives.*

## A SWALLOW AND OTHER BIRDS

THERE was a country fellow at work a sowing his grounds, and a swallow (being a bird famous for providence and foresight) call'd a company of little birds about her, and bad 'em take good notice what that fellow was a doing. You must know (says the swallow) that all the fowlers nets and snares are made of hemp, or flax; and that's the seed that he is now a sowing. Pick it up in time for fear of what may come on't. In short, they put it off, till it took root; and then again, till it was sprung up into the blade. Upon this, the swallow told 'em once for all, that it was not yet too late to prevent the mischief, if they would but bestir themselves, and set heartily about it; but finding that no heed was given to what she said; she e'en bad adieu to her old companions in the woods, and so betook herself to a city

64

life, and to the conversation of men. This flax and hemp came in time to be gather'd, and wrought, and it was this swallows fortune to see several of the very same birds that she had fore-warn'd, taken in nets, made of the very stuff she told them off. They came at last to be sensible of the folly of slipping their opportunity; but they were lost beyond all redemption first.

THE MORAL

*Wise men read effects in their causes, but fools will not believe them till 'tis too late to prevent the mischief. Delay in these cases is mortal.*

## LARGE PROMISES

THERE was a poor sick man, that according to the course of the world, when physicians had given him over, betook himself to his prayers, and vow'd a sacrifice of a thousand oxen ready down upon the nail, to either Apollo, or Æsculapius, which of the two would deliver him from this disease. Ah my dear, (says his wife) have a care what you promise, for where would you have these oxen if you should recover? Sweet heart (says he) thou talkst like a fool. Have the gods nothing else to do, dost think, then to leave their bus'ness, and come down to sue me in an action of debt? They restor'd him however for that bout, to make tryal of his honesty and good faith. He was no sooner up, but for want of living oxen, he made out his number upon past, and offer'd them up in form upon an altar. For this mockery, divine vengeance pursued him, and he had an apparition come to him in a dream, that bad him go and search in such a place near the coast, and he should find a considerable treasure. Away he went, and as he was looking for the mony fell into the hands of pyrates. He begg'd hard for his liberty, and offered a thousand talents of gold for his ransome; but they would not trust him, and

65

so he was carried away, and sold afterwards as a slave for as many groats.

THE MORAL

*The Dev'll was sick, the Dev'll a monk would be;*
*The Dev'll was well, the Dev'll a monk was he.*

## A SNAKE AND A FILE

THERE was a snake got into a smith's shop, and fell to licking of a file. She saw the file bloudy, and still the bloudyer it was, the more eagerly she lick'd it; upon a foolish fancy, that it was the file that bled, and that she her self had the better on't. In the conclusion, when she could lick no longer, she fell to biting; but finding at last that she could do no more good upon't with her teeth, then with her tongue, she fairly left it.

THE MORAL

*'Tis a madness to stand biting and snapping at any thing to no manner of purpose, more then the gratifying of an impotent rage, in the fancy of hurting another, when in truth, we only wound our selves.*

## A SMITH AND HIS DOG

A BLACKSMITH took notice of a cur he had, that would be perpetually sleeping, so long as his master was at his hammer; but whenever he went to dinner, the dog would be sure to make one. So he ask'd the dog the reason on't. What's the meaning of it, says he, that so long as I'm at the forge, you are still taking your nap; but so soon as my chops begin to walk, yours must be walking too for company? There's a time to sleep (says the dog) and a time to wake; and every thing is well done that is done in due season.

THE MORAL

*All creatures do naturally look to the main chance; that is to say, the bus'ness of food and propagation.*

66

## A FLEA AND A MAN

A FELLOW finding somewhat prick him, popt his finger upon the place, and it prov'd to be a flea. What art thou, says he, for an animal, to suck thy livelyhood out of my carcass? Why 'tis the livelyhood, (says the flea) that nature has allotted me, and my stinging is not mortal neither. Well, says the man, but 'tis troublesome however; and now I have ye, I'll secure ye for ever hurting me again, either little or much.

### THE MORAL

Live and let live *is the rule of common justice, but if people will be troublesome on the one hand, the obligation is discharg'd on the other.*

67

## A LYON AND A BULL

IN the days of yore, when bulls lived upon mutton, there was a lyon had a design upon a mighty bull, and gave him a very civil invitation to come and sup with him; for, says he, I have gotten a sheep, and you must needs take part on't. The bull promised, and went; but so soon as ever he saw what a clutter there was with huge, over-grown pots, pans, and spits, away he scowr'd immediately. The lyon presently call'd after him, and ask'd him, whither in such hast? Oh, says the bull, 'tis high time for me to be jogging, when I see such preparation: for this provision looks as if you were to have a bull for your supper, rather then a mutton.

### THE MORAL
*When a man has both an interest and an inclination to betray us, there's no trusting him.*

## A FATHER AND SONS

A COUNTRYMAN that liv'd handsomly in the world himself upon his honest labour and industry, was desirous his sons should do so after him; and being now upon his death-bed : My dear children (says he) I reckon my self bound to tell you before I depart, that there is a considerable treasure hid in my vineyard. Wherefore pray be sure to dig, and search narrowly for't when I am gone. The father dyes, and the sons fall immediately to work upon the vineyard. They turn'd it up over and over, and not one penny of mony to be found there; but the profit of the next vintage expounded the riddle.

### THE MORAL
*Good councell is the best legacy a father can leave to a child, and it is still the better, when it is so wrapt up, as to beget a curiosity as well as an inclination to follow it.*

68

## A GARDINER AND HIS DOG

A GARD'NER'S DOG dropt into a well, and his master let himself down to help him out again. He reach'd forth his hand to take hold of the dog, and the curr snapt him by the fingers : for he thought 'twas only to duck him deeper. The master went his way upon't, and e'en left him as he found him. Nay (says he) I'm well enough serv'd, to take so much pains for the saving of one that is resolv'd to make away himself.

### THE MORAL
*Obligations and benefits are cast away upon two sorts of people; those that do not understand them, and those that are not sensible of them.*

## A FOX THAT LOST HIS TAYLE

THERE was a fox taken in a trap, that was glad to compound for his neck by leaving his tayle behind him. It was so uncouth a sight, for a fox to appear without a tayle, that the very thought on't made him e'en weary of his life; for 'twas a loss never to be repair'd : but however for the better countenance of the scandal, he got the Master and Wardens of the Foxes Company to call a Court of Assistants, where he himself appear'd, and made a learned discourse upon the trouble, the uselessness, and the indecency of foxes wearing tayles. He had no sooner say'd out his say, but up rises a cunning snap, then at the bord, who desir'd to be enform'd, whether the worthy member that mov'd against the wearing of tayles, gave his advice for the advantage of those that had tayles, or to palliate the deformity and disgrace of those that had none.

### THE MORAL
*When a man has any notable defect, or infirmity about him, whether by nature, or by chance, 'tis the best of his play, to try the humour, if he can turn it into a fashion.*

69

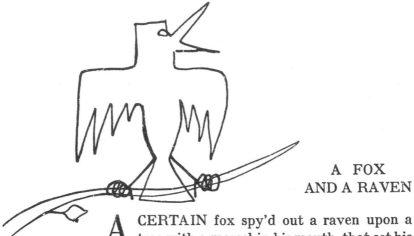

## A FOX
## AND A RAVEN

A CERTAIN fox spy'd out a raven upon a tree with a morsel in his mouth, that set his chops a watering; but how to come at it was the question. Ah thou blessed bird! (says he) the delight of gods, and of men! and so he lays himself forth upon the gracefulness of the ravens person, and the beauty of his plumes; his admirable gift of augury, &c. And now, says the fox, if thou hadst but a voice answerable to the rest of thy excellent qualities, the sun in the firmament could not shew the world such another creature. This nauseous flattery sets the raven immediately a gaping as wide as ever he could stretch, to give the fox a taste of his pipe; but upon the opening of his mouth, he drops his breakfast, which the fox presently chopt up and then bad him remember, that whatever he had said of his beauty, he had spoken nothing yet of his brains.

### THE MORAL

*There's hardly any man living that may not be wrought upon more or less by flattery: for we do all of us naturally overween in our own favour : but when it comes to be apply'd once to a vain fool, it makes him forty times an arranter sot than he was before.*

70

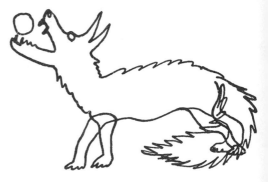

## AN OLD LION

A LION that in the days of his youth and strength, had been very outrageous and cruel, came in the end to be reduced by old age, and infirmity, to the last degree of misery, and contempt : insomuch that all the beasts of the forrest; some out of insolence, others in revenge, some in fine, upon one pretence, some upon another, fell upon him by consent. He was a miserable creature to all intents and purposes; but nothing went so near the heart of him in his distress, as to find himself batter'd by the heel of an asse.

### THE MORAL
*A Prince that does not secure friends to himself while he is in power and condition to oblige them, must never expect to find friends, when he is old and impotent, and no longer able to do them any good. If he governs tyrannically in his youth, he will be sure to be treated contemptuously in his age; and the baser his enemies are, the more insolent, and intolerable will be the affront.*

## AN IMPOSTOR TO THE ORACLE

THERE was a certain bantering droll that took a journey to Delphos, a purpose to try if he could put a trick upon Apollo. He carry'd a sparrow in his hand under his coat, and told the god, I have somewhat in my hand, says he, is it dead or living? If the oracle should say 'twas dead, he could shew it alive; if living, 'twas but squeezing it, and then 'twas dead. Now he that saw the malice of his heart gave him this answer : It shall e'en be which of the two you please; for 'tis in your choice to have it either the one or the other.

### THE MORAL
*Presumption leades people to infidelity in a trice, and so by insensible degrees to atheism : for when men have once cast off a reverence for religion, they are come within one step of laughing at it.*

71

## COCKS AND A PARTRIDGE

A COCK-MASTER bought a partridge, and turn'd it among his fighting cocks, for them to feed together. The cocks beat the partridge away from their meat, which she lay'd the more to heart, because it look'd like an aversion to her purely as a stranger. But the partridge finding these very cocks afterwards, cutting one another to pieces, she comforted her self with this thought, that she had no reason to expect they should be kinder to her, than they were to one another.

### THE MORAL

*'Tis no wonder to find those people troublesome to strangers, that cannot agree among themselves. They quarrel for the love of quarrelling; and provided the peace be broken, no matter upon what ground, or with whom.*

## MERCURY AND A TRAVELLER

O NE that was just entring upon a long journey, took up a fancy of putting a trick upon Mercury. He say'd him a short prayer for the bon voyage, with a promise, that the god should go halfe with him in whatever he found. Some body had lost a bag of dates and almonds, it seems, and it was his fortune to find it. He fell to work upon 'em immediately, and when he had eaten up the kernels, and all that was good of them, himself, he lay'd the stones, and the shells upon an altar; and desir'd Mercury to take notice that he had perform'd his vow. For, says he, here are the outsides of the one, and the insides of the other, and there's the moiety I promis'd ye.

### THE MORAL

*Men talk as if they believe in God, but they live as if they thought there were none; for their very prayers are mockeries, and their vows and promises are no more then* words of course, *which they never intended to make good.*

72

# A DOG, A SHEEP, AND A WOLF

A DOG brought an action of the case against a sheep, for some certain measures of wheat, that he had lent him. The plaintiff prov'd the debt by three positive witnesses, the wolf, the

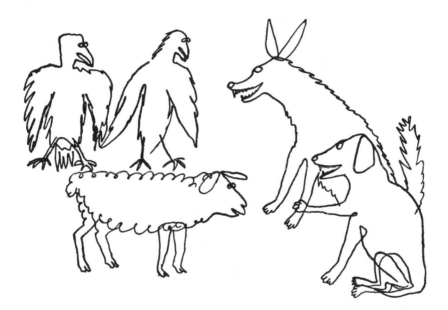

kite, and the vultur, (testes probi and legales). The defendent was cast into costs and damages, and forc'd to sell the wool off his back to satisfie the creditor.

### THE MORAL
*'Tis not a straw matter whether the main cause be right or wrong, or the charge true or false; where the bench, jury and witnesses are in a conspiracy against the pris'ner.*

## A LARK AND HER YOUNG ONES

THERE was a brood of young larks in the corn, and the dam, when she went abroad to forage for them, laid a strict charge upon her little ones, to pick up what news they could get against she came back again. They told her at her return, that the owner of the field had been there, and order'd his neighbours to come and reap the corn. Well, says the old one, ther's no danger yet then. They told her the next day that he had been there again, and desir'd his friends to do't. Well, well, says she, there's no hurt in that neither, and so she went out a progging for provisions again as before. But upon the third day, when they told their mother, that the master and his son appointed to come the next morning about it themselves : nay then, says she, 'tis time to look about us : as for the neighbours and the friends, I fear 'em not : but the master I'm sure will be as good as his word; for 'tis his own bus'ness.

## THE STAG AND THE OXEN

A STAG that was hard set by the huntsmen, betook himself to a stall for sanctuary, and prevail'd with the oxen to conceal him the best they could, so they cover'd him with straw, and by and by in comes the keeper to dress the cattel, and to feed them; and when he had done his work he went his way without any discovery. The stag reckon'd himself by this time to be out of all danger; but one of the oxen that had more brains than his fellows, advis'd him not to be too confident neither; for the servant, says he, is a puzzling fool that heeds nothing; but when my master comes, he'll have an eye here and there and every where, and will most certainly find ye out. Upon the very

speaking of the word, in comes the master, and he spies out twenty faults, I warrant ye; this was not well, and that was not well; till at last, as he was prying and groping up and down, he felt the horns of the stag under the straw, and so made prize of him.

THE MORAL OF THE TWO FABLES ABOVE

*He that would be sure to have his bus'ness well done, must either do it himself, or see the doing of it; beside that many a good servant is spoil'd by a careless master.*

## A DOG AND A SHADOW

AS a dog was crossing a river, with a morsel of good flesh in his mouth, he saw (as he thought) another dog under the water, upon the very same adventure. He never consider'd that the one was only the image of the other; but out of a greediness to get both, he chops at the shadow, and loses the substance.

### THE MORAL

All covet, all lose; *which may serve for a reproof to those that govern their lives by fancy and appetite, without consulting the honor, and the justice of the case.*

## A KINGFISHER

THE kingfisher is a solitary bird, that wonts commonly by the water-side, and nestles in hollow banks to be out of reach of the fowlers. One of these birds happen'd to be forraging abroad for her young ones, and in the interim, comes a raging torrent, that washes away nest, birds and all. Upon her return, finding how 'twas with her, she brake out into this exclamation : Unhappy creature that I am! to fly from the bare apprehension of one enemy, into the mouth of another.

### THE MORAL

*'Tis many a wise man's hap, while he is providing against one danger to fall into another : and for his very providence to turn to his destruction.*

## DEATH AND AN OLD MAN

AN old man that had travell'd a great way under a huge burden of sticks, found himself so weary, that he cast it down, and call'd upon Death to deliver him from a more miserable life. Death came presently at his call, and asked him his bus'ness. Pray good sir, says he, do me but the favour to help me up with my burden again.

THE MORAL

*Men call upon death, as they do upon the devil : when he comes they're affraid of him.*

## A FOX AND A CROCODILE

THERE happen'd a contest betwixt a fox and a crocodile, upon the point of bloud and extraction. The crocodile amplify'd wonderfully upon his family, for the credit of his ancestors. Friend (says the fox, smiling upon't) there will need no herald to prove your gentility; for you carry the marks of your original in your very skin.

THE MORAL

*Great boasters and lyars have the fortune still some way or other to disprove themselves.*

## A FOWLER AND A BLACK–BIRD

AS a fowler was bending his net, a black-bird call'd to him at a distance, and ask'd him what he was a doing. Why says he, I am laying the foundations of a city; and so the birdman drew out of sight. The black-bird mistrusting nothing, flew presently to the bait in the net, and was taken; and as the man came running to lay hold of her; Friend, says the poor black-bird, if this be your way of building, you'l have but few inhabitants.

THE MORAL

*There is no sham so gross, but it will pass upon a weak man that is pragmatical, and inquisitive.*

76

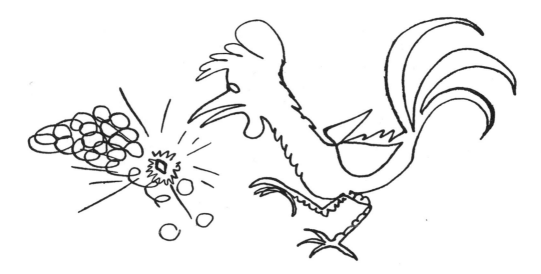

## A COCK AND A DIAMOND

AS a cock was turning up a dunghill, he spy'd a diamond. Well (says he to himself) this sparkling foolery now to a lapidary in my place, would have been the making of him; but as to any use or purpose of mine, a barley-corn had been worth forty on't.

### THE MORAL

*He that's industrious in an honest calling, shall never fail of a blessing. 'Tis the part of a wise man to prefer things necessary before matters of curiosity, ornament, or pleasure.*

## A LION, AN ASS, &c., A HUNTING

A LION, an ass, and some other of their fellow-forresters, went a hunting one day; and every one to go share and share-like in what they took. They pluck'd down a stag, and cut him up into so many parts; but as they were entering upon the dividend, Hands-off says the lion : this part is mine by the privilege of my quality : this, because I'll have it in spite of your teeth : this again, because I took most pains for't; and if you dispute the fourth, we must e'en pluck a crow about it. So the confederates mouths were all stopt, and they went away as mute as fishes.

THE MORAL

*There's no entring into leagues or partnerships, with those that are either too powerful, or too crafty for us. He that has the staff in his hand will be his own carver.* Bought wit is best.

## A CROW AND A MUSCLE

THERE was one of your royston-crows, that lay battering upon a muscle, and could not for his blood break the shell to come at the fish. A carrion-crow, in this interim, comes up, and tells him, that what he could not do by force, he might do by stratagem. Take this muscle up into the air, says the crow, as high as you can carry it, and then let him fall upon that rock there; his own weight, you shall see, shall break him. The roystoner took his advice, and it succeeded accordingly; but while the one was upon wing, the other stood lurching upon the ground, and flew away with the fish.

THE MORAL

Charity begins at home, *they say; and most people are kind to their neighbours for their own sakes.*

78

## A BOASTING MULE

THERE was a favourite-mule, that was high fed, and in the pride of flesh and mettle, would still be bragging of his family, and his ancestors. My father (says he) was a coarser, and though I say it that should not say't, I my self take after him. He had no sooner spoke the words, but he was put to the tryal of his heels, and did not only shew himself a jade; but in the very heat of his ostentation, his father fell a braying, which minded him of his original, and the whole field made sport on't, when they found him to be the son of an asse.

THE MORAL

*A bragging fool that's raised out of a dunghill, and sets up for a man of quality, is asham'd of nothing in this world but of his own father.*

## A DOG IN A MANGER

A CHURLISH envious cur was gotten into a manger and there lay growling and snarling to keep the horses from their provender. The dog eat none himself, and yet rather ventured the starving his own carcase then he would suffer any thing else to be the better for't.

THE MORAL

*Envy pretends to no other happiness then what it derives from the misery of other people, and will rather eate nothing it selfe then not starve those that would.*

## A FOWLER AND A PIGEON

AS a country fellow was making a shoot at a pigeon, he trod upon a snake that bit him by the leg. The surprize startled him, and away flew the bird.

THE MORAL

*We are to distinguish betwixt the benefits of good will, and those of providence : for the latter are immediately from heaven, where no human intention intervenes.*

## A SICK KITE AND HER MOTHER

PRAY mother (says a sick kite) give over these idle lamentations, and let me rather have your prayers. Alas! my child, (says the dam) which of the gods shall I go to, for a wretch that has robb'd all their altars?

THE MORAL

*Nothing but the conscience of a virtuous life can make death easie to us; wherefore there's no trusting to the distraction of an agonizing, and a death-bed repentance.*

## A HEN AND A SWALLOW

THERE was a foolish hen that sat brooding upon a nest of snakes eggs. A swallow, that observ'd it, went and told her the danger on't. Little do you think, says she, what you are at this instant a doing, and that you are just now hatching your own destruction; for this good office will be your ruine.

THE MORAL

*'Tis the hard fortune of many a good natur'd man to* breed up a bird to peck out his own eyes, *in despite of all cautions to the contrary.*

## AN ASSE AND A WOLF

AN asse had got a thorn in's foot, and for want of a better surgeon, who but a wolf at last, to draw it out with his teeth! The asse was no sooner eas'd, but he gave his operator such a lick under the ear with his sound foot for his pains, that he stunn'd him, and so went his way.

## A HORSE AND A LION

THERE was an old hungry lion would fain have been dealing with a piece of good horse-flesh that he had in his eye; but the nag he thought would be too fleet for him, unless he could supply the want of heels by artifice and address. He puts himself into the garb, and habit of a professor of physick, and

according to the humour of the world, sets up for a doctor of the college. Under this pretext, he lets fall a word or two by way of discourse, upon the subject of his trade; but the horse smelt him out, and presently a crotchet came in his head how he might countermine him. I got a thorn in my foot t'other day, says the horse, as I was crossing a thicket, and I'm e'en quite lame on't. Oh, says the new physician, do but hold up your leg a little, and I'll cure ye immediately. The lion presently puts himself in posture for the office; but the patient was too nimble for his doctor, and so soon as ever he had him fair for his purpose, gave him so terrible a rebuke upon the forehead with his heel, that he laid him at his length, and so got off with a whole skin, before the other could execute his design.

### THE MORAL OF THE TWO FABLES ABOVE

Harm watch, harm catch, *is but according to the common rule of equity and retaliation, and a very warrantable way of deceiving the deceiver.*

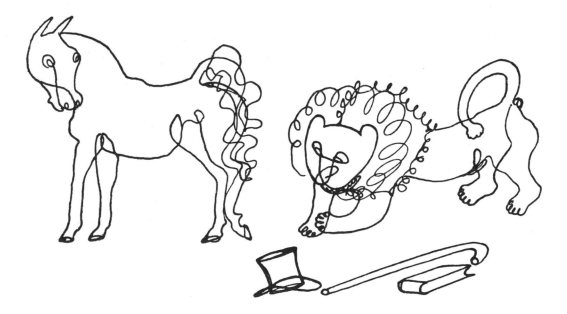

# A WOLFE AND A SHEEP

A WOLFE that lay licking of his wounds, and extremely faint, and ill, upon the biting of a dog, call'd out to a sheep that was passing by, Heark ye friend (says he) if thou wouldst but help me to a soup of water out of that same brook there, I could make a shift to get my self somewhat to eat. Yes, says the sheep, I make no doubt on't. But when I bring ye drink, my carcase shall serve ye for meat to't.

### THE MORAL

*It is a charitable and a christian office to relieve the poor and the distressed; but this duty does not extend to sturdy beggars, that while they are receiving alms with one hand, are ready to beat out a man's brains with the other.*

# A SHEPHERD AND A WOLVES WHELP

A SHEPHERD took a sucking whelp of a wolfe, and train'd it up with his dogs. This whelp fed with 'em; grew up with 'em, and whensoever they went out upon the chace of a wolfe, the whelp would be sure to make one. It fell out sometimes that the wolfe scap'd, and the dogs were forc'd to go home again : but this domestique wolfe would be still hunting on, 'till he came up to his brethren where he took part of the prey with them; and so back again to his master. It happen'd now and then that the wolves abroad were pretty quiet for a fit : so that this whelp of a wolfe was fain to make bold ever and anon with a sheep in private by the by; but in the conclusion, the shepherd came to find out the roguery, and hang'd him up for his pains.

### THE MORAL

*False men are no more to be reclaim'd then wolves, and the leven of the predecessors sowres the bloud, in the very veins of the whole family.*

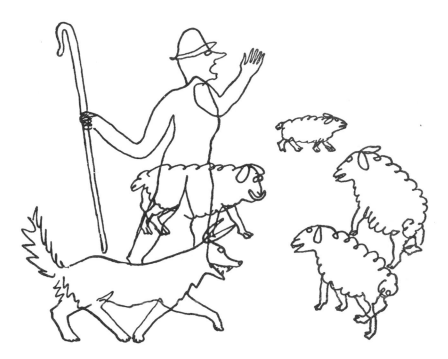

## A BOY AND FALSE ALARUMS

A SHEPHERD BOY had gotten a roguy trick of crying (a wolfe, a wolfe) when there was no such matter, and fooling the country people with false alarums. He had been at this sport so many times in jest, that they would not believe him at last when he was in earnest : and so the wolves brake in upon the flock, and worry'd the sheep at pleasure.

### THE MORAL
*He must be a very wise man that knows the true bounds and measures of fooling, with a respect to time, place, matters, persons, Etc. But religion, business and cares of consequence must be excepted out of that sort of liberty.*

## A HOUND AND A MASTIFFE

THERE was a man had two dogs; one for the chace, t'other to look to the house; and whatever the hound took abroad, the house-dog had his part on't at home. T'other grumbled at it, that when he took all the pains, the mastiffe should reap the fruit of his labours. Well, says the house-dog, that's none of my fault, but my masters, that has not train'd me up to work for my self, but to eat what others have provided for me.

### THE MORAL
*Fathers and masters have a great deal to answer for, if their children and servants do not do as they should do.*

## THIEVES THAT STOLE A COCK

A BAND of thieves brake into a house once, and found nothing in't to carry away, but one poor cock. The cock said as much for himself as a cock could say; but insisted chiefly upon the services of his calling people up to their work, when 'twas time to rise. Sirrah (says one of the thieves) you had better have let that argument alone; for your waking the family spoils our trade, and we are to be hang'd forsooth for your bawling.

### THE MORAL
*That which is one body's meat, is another body's poyson; as the trussing up of thieves is the security of honest men. One foolish word is enough to spoil a good cause, and 'tis many a man's fortune to cut his own throat with his own argument.*

## A FOX AND A SICK LYON

A CERTAIN lyon that had got a politique fit of sickness, made it his observation, that of all the beasts in the forrest, the fox never came at him : and so he wrote him word how ill he was, and how mighty glad he should be of his company, upon the score of ancient friendship and acquaintance. The fox return'd the

84

complement with a thousand prayers for his recovery; but as for waiting upon him, he desir'd to be excus'd; for (says he) I find the traces of abundance of feet going in to your majesties palace, and not one that comes back again.

<div align="center">THE MORAL</div>

*The kindnesses of ill natur'd and designing people, should be thoroughly consider'd, and examin'd, before we give credit to them.*

## A FOWLER AND A PARTRIDGE

A FOWLER had taken a partridge, and the bird offer'd her self to decoy as many of her companions into the snare as she could, upon condition that he would but give her quarter. No, says he, you shall dye the rather for that very reason, because you would be so base as to betray your friends to save your self.

<div align="center">THE MORAL</div>

*Of all scandalous and lewd offices, that of a traytor is certainly the basest; for it undermines the very foundations of society.*

## A WOLFE AND A KID

A WOLFE spy'd out a straggling kid, and pursu'd him. The kid found that the wolfe was too nimble for him, and so turn'd and told him: I perceive I am to be eaten, and I would gladly die as pleasantly as I could : wherefore, pray give me but one touch of your pipe before I go to pot. The wolfe play'd, and the kid danc'd, and the noise of the pipe brought in the dogs upon him. Well (says the wolfe) this 'tis when people will be meddling out of their profession. My bus'ness was to play the butcher, not the piper.

<div align="center">THE MORAL</div>

*When a crafty knave is infatuated, any silly wretch may put tricks upon him.*

# A MAN AND TWO WIVES

IT was now cuckow-time, and a certain middle ag'd man, that was half-gray, half-brown, took a fancy to marry two wives, of an age one under another, and happy was the woman that

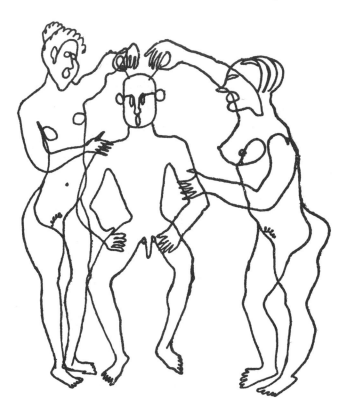

could please him best. They took mighty care of him to all manner of purposes, and still as they were combing the good

man's head, they'd be picking out here and there a hair to make it all of a colour. The matronly wife, she pluck'd out all the brown hairs, and the younger the white : so that they left the man in the conclusion no better then a bald buzzard betwixt them.

THE MORAL

*'Tis a much harder thing to please two wives then two masters; and he's a bold man that offers at it.*

## A MOUNTAIN IN LABOUR

WHEN mountains cry out, people may well be excus'd the apprehension of some prodigious birth. This was the case here in the fable. The neighbourhood were all at their wits end, to consider what would be the issue of that labour, and instead of the dreadful monster that they expected, out comes at last a ridiculous mouse.

THE MORAL

*Much ado about nothing.*

## AN ASSE, A LYON, AND A COCK

AS a cock and an asse were feeding together, up comes a lyon open-mouth toward the asse : the cock presently cryes out; away scoures the lyon, and the asse after him. Now 'twas the crowing of the cock that frighted the lyon, not the braying of the asse, as that stupid animal vainly fancy'd to himself, for so soon as ever they were gotten out of the hearing of the cock, the lyon turn'd short upon him, and tore him to pieces, with these words in his mouth : Let never any creature hereafter that has not the courage of a hare, provoke a lyon.

THE MORAL

*The force of unaccountable aversions, is insuperable. The fool that is wise and brave only in his own conceit, runs on without fear or wit, but noise does no bus'ness.*

87

## A FORTUNE–TELLER

THERE was a kind of a petty conjurer, that made it his profession to resolve questions, and tell fortunes, and he held forth in the market-place. Word was brought him, in the very middle of his schemes and calculations, that his house was robb'd; and so away he scours immediately to learn the truth on't. As he was running home in all haste a droll takes him up by the way, with this short question, Friend (says he) how come you to be so good at telling other peoples fortunes, and know so little of your own?

## A CUNNING WOMAN

A CERTAIN dame that pass'd in the world under the name of a cunning woman, took upon her to avert divine judgments, and to foretell strange things to come. She play'd the counterfeit witch so long, till in the conclusion, she was taken up, arraign'd, try'd, convicted, condemned to dye, and at last executed for a witch indeed. D'ye hear, good woman (says one to her, as she was upon the way to her execution) are the gods so much easier then the judges, that you should be able to make them do any thing for ye, and yet could not prevail with the bench for the saving of your own life?

## AN ASTROLOGER AND A TRAVELLER

A CERTAIN starr-gazer had the fortune, in the very height of his celestial observations, to stumble into a ditch: a sober fellow passing by, gave him a piece of wholesome counsel. Friend, says he, make a right use of your present misfortune; and pray, for the future, let the starrs go on quietly in their courses, and do you look a little better to the ditches.

88

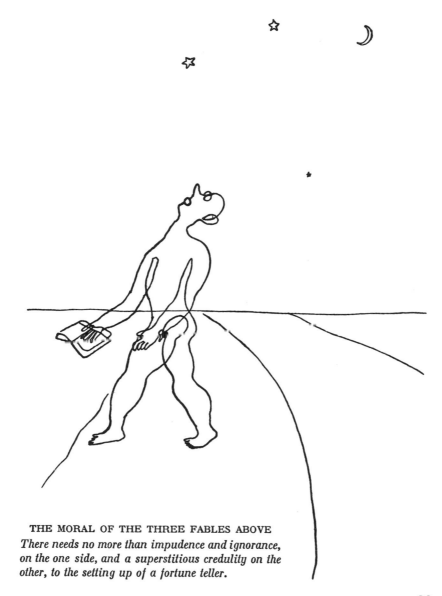

**THE MORAL OF THE THREE FABLES ABOVE**
*There needs no more than impudence and ignorance,*
*on the one side, and a superstitious credulity on the*
*other, to the setting up of a fortune teller.*

## A BOAR AND A HORSE

A BOAR happen'd to be wallowing in the water where a horse was going to drink, and there grew a quarrel upon't. The horse went presently to a man, to assist him in his revenge. They agreed upon the conditions, and the man immediately arm'd

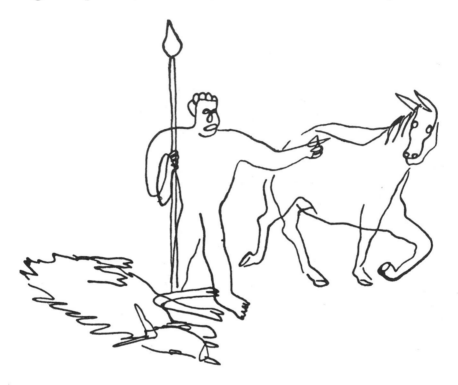

himself, and mounted the horse, who carry'd him to the boare, and had the satisfaction of seeing his enemy kill'd before his face. The horse thank'd the cavalier for his kindness, but as he was

just about to take leave, the man say'd he should have further occasion for him, and so order'd him to be ty'd up in the stable. The horse came by this time, to understand, that his liberty was gone, and no help for't, and that he had pay'd dear for his revenge.

## A STAG AND A HORSE

UPON a dispute betwixt a stag and a horse about a piece of pasture, the stag got the better on't, and beat the other out of the field. The horse, upon this affront, advis'd with a man what course to take; who told him, that if he would submit to be bridled, and sadled, and take a man upon his back with a lance in his hand, he would undertake to give him the satisfaction of a revenge. The horse came to his terms, and for the gratifying of a present passion, made himself a slave all the days of his life. Stesichorus made use of this fable, to divert the Himerenses from chusing Phalaris the tyrant for their general. This horse's case, says he, will be yours, if you go on with your proposals. 'Tis true, you'l have your revenge, but you'l lose your liberties; upon which words the motion fell.

### THE MORAL OF THE TWO FABLES ABOVE
*Let every man take a true measure of himself, what he is able to do, and what not; before he comes to any peremptory resolution how to proceed. He is a madman, that to avoid a present, and a less evil, runs blindfolded into a greater; and for the gratifying of a froward humour, makes himself a slave all the days of his life.*

## A MAN AND A WOODEN GOD

A MAN that had a great veneration for an image he had in his house, found, that the more he pray'd to't to prosper him in the world, the more he went down the wind still. This put him into such a rage, to lye dogging at his prayers so much, and so

91

long, to so little purpose, that at last he dasht the head on't to
pieces against the wall; and out comes a considerable quantity
of gold.   Why this 'tis, says he, to adore a perverse and insensible
deity, that will do more for blowes than for worship.

<center>THE MORAL</center>
*Most people, clergy as well as laity, accommodate their religion to their profit, and
reckon that to be the best church that there's most to be got by.*

## A MAN BIT BY A DOG

ONE that was bitten by a dog, was advis'd, as the best
remedy in the world, to dip a piece of bread in the bloud of
the wound, and give it the dog to eate.   Pray hold your hand a
little (says the man) unless y'ave a mind to draw all the dogs in
the town upon me; for that will certainly be the end on't, when
they shall find themselves rewarded instead of punish'd.

<center>THE MORAL</center>
*Good nature is a great misfortune, where it is not manag'd with prudence.  Christian
charity, 'tis true, bids us return good for evil; but it does not oblige us yet to reward
where we should punish.*

## AN EAGLE AND A MAN

A MAN took an eagle, pelted her wings, and put her among
his hens.   Somebody came and bought this eagle, and
presently new feather'd her.   She made a flight at a hare, truss'd
it, and brought it to her benefactor.   A fox perceiving this, came
and gave the man a piece of good councell.   Have a care, says
Reynard, of putting too much confidence in this eagle; for she'll
go neare, one time or other else, to take you for a hare.   Upon
this advice the man plum'd the eagle once again.

<center>THE MORAL</center>
*Persons and humours may be jumbled and disguis'd, but nature is like quick-
silver, that will never be kill'd.*

**92**

## A WOLF AND A CRANE

A WOLF had got a bone in's throat, and could think of no better instrument

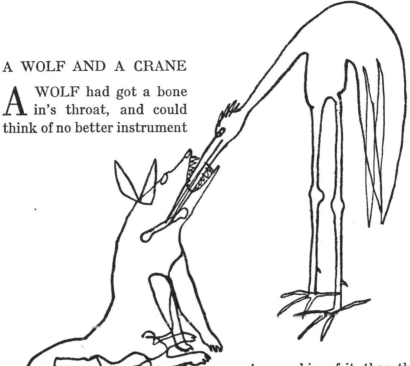

to ease him of it, than the bill of a crane; so he went and treated with a crane to help him out with it, upon condition of a very considerable reward for his pains. The crane did him the good office, and then claim'd his promise. Why how now, impudence! (says t'other) do you put your head into the mouth of a wolf, and then, when y'ave brought it out again safe and sound, do you talk of a reward? Why sirrah, you have your head again, and is not that a sufficient recompence?

### THE MORAL

*One good turn, they say, requires another: but yet he that has to do with wild beasts (as some men are no better) and comes off with a whole skin, let him expect no other reward.*

## A SOW AND A DOG

THERE pass'd some hard words betwixt a sow and a dog, and the sow swore by Venus, that she'd tear his guts out, if he did not mend his manners. Ay, says the dog, you do well to call upon her for your patroness, that will not so much as endure any creature about her that eates swines flesh. Well (says the sow) and that's a token of her love, to hate any thing that hurts me; but for dogs flesh, 'tis good neither dead, nor living.

### THE MORAL
*Where the matter in controversy will not bear an argument, 'tis a turn of art to bring it off with a paradox.*

## A CAMEL PRAYING FOR HORNS

IT stuck filthily in the camel's stomach, that bulls, stags, lions, bears, and the like, should be armed with horns, teeth, and claws, and that a creature of his size should be left naked and defenceless. Upon this thought he fell down upon his marybones, and begg'd of Jupiter to give him a pair of horns, but the request was so ridiculous that Jupiter, instead of horning him, order'd him to be cropt, and so punish'd him with the loss of his ears which nature had allow'd him, for being so unreasonable as to ask for horns, that Providence never intended him.

## A FOX AND A HARE TO JUPITER

A FOX and a hare presented a petition to Jupiter. The fox pray'd for the hare's swiftness of foot, and the hare for the fox's craft, and wilyness of address. Jupiter told them, that since every creature had some advantage or other peculiar to it self, it would not stand with divine justice, that had provided so well for every one in particular, to conferr all upon any one.

## A PEACOCK TO JUNO

THE peacock, they say, lay'd it extremely to heart, that
being Juno's darling-bird, he had not the nightingale's voice
superadded to the beauty of his own plumes. Upon this subject
he petition'd his patroness, who gave him for answer, that Prov-
idence had assign'd every bird its proportion, and so bad him
content himself with his lot.

### THE MORAL OF THE THREE FABLES ABOVE

*The bounties of heaven are in such manner distributed, that every living creature
has its share; beside, that to desire things against nature, is effectually to blame the
very author of nature it self.*

# A TRUMPETER TAKEN PRISONER

UPON the rout of an army there was a trumpeter made a pris'ner, and as the soldiers were about to cut his throat; Gentlemen (says he) why should you kill a man that kills no body? You shall die the rather for that, cries one of the company, for being so mean a rascal, as to set other people together by the ears, without fighting your self.

### THE MORAL

*He that provokes and incites mischief, is the doer of it. 'Tis the man that kills me, the bullet is only a passive instrument to serve his end that directs it.*

# A HORSE AND AN ASSE

IN the days of old, when horses spoke Greek and Latin, and asses made syllogisms, there happen'd an encounter upon the road betwixt a proud pamper'd jade in the full course of his carriere, and a poor creeping ass, under a heavy burden, that had chopt into the same track with him. Why, how now sirrah, says he, d'ye not see by these arms, and trappings, to what master I belong? And d'ye not understand that when I have that master of mine upon my back, the whole weight of the State rests upon my shoulders? Out of the way thou slavish insolent animal, or I'll tread thee to dirt. The wretched asse immediately slunck aside, with this envious reflexion betwixt his teeth. [What would I give to change conditions with that happy creature there. This fancy would not out of the head of him, 'till it was his hap some few days after to see this very horse doing drudgery in a common dung-cart. Why how now friend (says the asse) how comes this about? Only the chance of the war, says the other ; I was a soldiers horse, you must know, and my

96

master carry'd me into a battel, where I was shot, hack'd, and maim'd; and you have here before your eyes the catastrophe of my fortune.

THE MORAL

*The folly, and the fate, of pride and arrogance.   The mistake of placing happiness in any thing that may be taken away. and the blessing of freedom in a mean estate.*

## A BAT AND A WEAZLE

A WEAZLE had seiz'd upon a bat, and the bat begg'd for life. No, no, says the weazle, I give no quarter to birds. Ay (says the bat) but I'm a mouse you see; look on my body else : and so she got off for that bout. The same bat had the fortune to be taken a while after by another weazle; and there the poor bat was forc'd to beg for mercy once again. No, says the weazle, no mercy to a mouse. Well (says t'other) but you may see by my wings that I'm a bird; and so the bat scap'd in both capacities, by playing the trimmer.

## A BAT, BIRDS, AND BEASTS

UPON a desperate and doubtful battel betwixt the birds and the beasts, the bat stood neuter, 'till she found that the beasts had the better on't, and then went over to the stronger side. But it came to pass afterward (as the chance of war is various) that the birds rally'd their broken troups, and carry'd

the day; and away she went then to t'other party, where she was try'd by a council of war as a deserter; stript, banish'd, and finally condemn'd never to see daylight again.

## AN ESTRICHE, BIRDS, AND BEASTS

THE estriche is a creature that passes in common reputation, for half-bird, half-beast. This amphibious wretch happen'd to be taken twice the same day, in a battel betwixt the birds and the beasts, and as an enemy to both parties. The birds would have him to be a beast, and the beasts concluded him to be a bird; but upon shewing his feet to prove that he was no bird, and upon shewing his wings, and his beak, to prove that he was no beast, they were satisfy'd upon the whole matter, that though he seem'd to be both, he was yet in truth neither the one, nor the other.

### THE MORAL OF THE THREE FABLES ABOVE

*Trimming in some cases, is foul, and dishonest; in others, laudable; and in some again, not only honest, but necessary. The nicety lies in the skill of distinguishing upon cases, times, and degrees.*

## A GALL'D ASS AND A RAVEN

AS an ass with a gall'd back was feeding in a meadow, a raven pitch'd upon him, and there sate, jobbing of the sore. The ass fell a frisking and braying upon't; which set a groom that saw it at a distance, a laughing at it. Well! (says a wolfe that was passing by) to see the injustice of the world now! A poor wolfe in that ravens place, would have been persecuted, and hunted to death presently; and 'tis made only a laughing-matter, for a raven to do the same thing would have cost a wolfe his life.

### THE MORAL
*One man may better steal a horse, then another look over the hedge.*

## AN ASSE, AN APE, AND A MOLE

AN asse and an ape were conferring griev-
ances. The asse complain'd mightily for
want of horns, and the ape was as much troubled
for want of a tail. Hold your tongues both of ye,

says the mole, and be thankful for what you have, for the poor
moles are stark blind, and in a worse condition than either of ye.

# THE HARES AND THE FROGS

ONCE upon a time the hares found themselves mightily unsatisfy'd with the miserable condition they liv'd in, and call'd a council to advise upon't. Here we live, says one of 'em, at the mercy of men, dogs, eagles, and I know not how many other creatures and vermine, that prey upon us at pleasure; perpetually in frights, perpetually in danger; and therefore I am absolutely of opinion that we had better die once for all, than live at this rate in a continual dread that's worse than death it self. The motion was seconded and debated, and a resolution immediately taken, one and all, to drown themselves. The vote was no sooner pass'd, but away they scudded with that determination to the next lake. Upon this hurry, there leapt a whole shoal of frogs from the bank into the water, for fear of the hares. Nay, then my masters, says one of the gravest of the company, pray let's have a little patience. Our condition I find is not altogether so bad as we fancy'd it; for there are those you see that are as much afraid of us, as we are of others.

### THE MORAL OF THE TWO FABLES ABOVE

*There's no contending with the orders and decrees of Providence. He that made us knows what's fittest for us; and every man's own lot (well understood and manag'd) is undoubtedly the best.*

## A SNAKE AND A CRAB

THERE was a familiarity contracted betwixt a snake and a crab. The crab was a plain dealing creature that advis'd his companion to give over shuffling and doubling, and to practice good faith. The snake went on in his old way : so that the crab finding that he would not mend his manners, set upon him in his

sleep, and strangled him; and then looking upon him as he lay dead at his length : This had never befall'n ye, says he, if you had but liv'd as straight as you dy'd.

THE MORAL

*There's nothing more agreeable in conversation, then a franke open way of dealing, and a simplicity of manners.*

## A STAG WITH ONE EYE

A ONE-EYED-STAG that was affraid of the huntsmen at land, kept a watch that way with t'other eye, and fed with his blind side still toward an arm of the sea, where he thought there was no danger.  In this prospect of security, he was struck with an arrow from a boat, and so ended his days with this lamentation : Here am I destroy'd, says he, where I reckon'd my self to be safe on the one hand; and no evil has befal'n me, where I most dreaded it, on the other.

THE MORAL

*We are lyable to many unlucky accidents that no care or foresight can prevent : but we are to provide however the best we can against them, and leave the rest to providence.*

## WASPS, PARTRIDGES, AND A HUSBANDMAN

A FLIGHT of wasps, and a covy of partridges that were hard put to't for water, went to a farmer, and begg'd a soup of him to quench their thirst.  The partridges offer'd to dig his vineyard for't, and the wasps to secure him from thieves.  Pray hold your hand, says the good man; I have oxen and dogs that do me these offices already, without standing upon terms.  And therefore it will become me to provide for them in the first place.

THE MORAL

Charity begins at home, *but the necessary duty of it in one place, does not discharge the christian exercise of it in another.*

102

# A FOX AND A GOAT

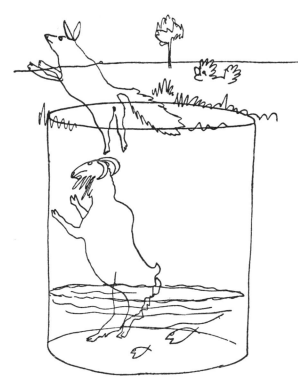

A FOX and a goat went down by consent into a well to drink, and when they had quench'd their thirst, the goat fell to hunting up and down which way to get back again. Oh! says Reynard, never trouble your head how to get back, but leave that to me. Do but you raise your self upon your hinder legs with your fore-feet close to the wall, and then stretch out your head : I can easily whip up to your horns, and so out of the well, and draw you after me. The goat puts himself in posture immediately as he was directed, gives the fox a lift, and so out he springs; but Reynard's bus'ness was now only to make sport with his companion instead of helping him. Some hard words the goat gave him, but the fox puts off all with a jest. If you had but half so much

brains as you have beard, says he, you would have bethought your self how to get up again before you went down.

THE MORAL

*A wise man will debate every thing pro and con before he comes to fix upon any resolution. He leaves nothing to chance more than needs must. There must be no bantering out of season.*

## JUPITER AND A BEE

A BEE made Jupiter a present of a pot of hony, which was so kindly taken, that he bad her ask what she would, and it should be granted her. The bee desir'd, that where ever she should set her sting, it might be mortal. Jupiter was loath to leave mankind at the mercy of a little spiteful insect, and so bad her have a care how she kill'd any body; for what person soever she attacqu'd, if she left her sting behind her, it should cost her her life.

THE MORAL

*Spiteful prayers are no better than curses in a disguise, and the granting of them turns commonly to the mischief of the petitioner.*

## A WOLF, KID, AND GOAT

A GOAT that was going out one morning for a mouthful of fresh grass, charg'd her kid upon her blessing, not to open the door till she came back, to any creature that had not a beard. The goat was no sooner out of sight, but up comes a wolf to the door, that had over-heard the charge; and in a small pipe calls to the kid to let her mother come in. The kid smelt out the roguery, and bad the wolf shew his beard, and the door should be open to him.

THE MORAL

*There never was any hypocrite so disguis'd, but he had some mark or other yet to be known by.*

104

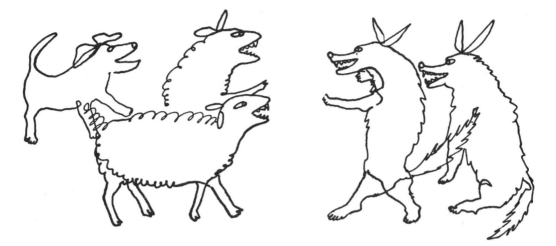

## A LEAGUE BETWIXT THE WOLVES AND THE SHEEP

THERE was a time when the sheep were so hardy as to wage war with the wolves; and so long as they had the dogs for their allies, they were, upon all encounters, at least a match for their enemies. Upon this consideration, the wolves sent their ambassadors to the sheep, to treat about a peace, and in the mean time there were hostages given on both sides; the dogs on the part of the sheep, and the wolves whelps on the other part, 'till matters might be brought to an issue. While they were upon treaty, the whelps fell a howling; the wolves cryed out treason; and pretending an infraction in the abuse of their hostages, fell upon the sheep immediately without their dogs, and made them pay for the improvidence of leaving themselves without a guard.

### THE MORAL

*'Tis senseless to the highest degree to think of establishing an alliance among those that nature her self has divided, by an inconciliable disagreement. Beside, that a foolish peace is much more destructive than a bloody war.*

## APPLES AND HORSE–TURDS

UPON a very great fall of rain, the current
carry'd away a huge heap of apples, to-
gether with a dunghill that lay in the water-course.
They floated a good while together like brethren
and companions; and as they went thus dancing
down the stream, the horse-turds would be every
foot crying out still, Alack a day! How we apples
swim!

## A PEACH, AN APPLE, AND A BLACKBERRY

THERE happen'd a controversie once betwixt a peach, and an apple, which was the fairer fruit of the two. They were so loud in their discourse, that a blackberry from the next hedg, over-heard them. Come (says the black-berry) we are all friends, and pray let's have no jangling among our selves.

THE MORAL OF THE TWO FABLES ABOVE

*Every thing would be thought greater in the world then it is, and the root of it is this, that it first thinks it self so.*

107

## A BOY AND HIS MOTHER

A SCHOOL–BOY brought his mother a book that he had
stoll'n from one of his fellows.  She was so far from correct-
ing him for't, that she rather encourag'd him.  As he grew bigger,
he would be still keeping his hand in use with somewhat of

greater value, till he came at last to be taken in the matter, and brought to justice for't. His mother went along with him to the place of execution, where he got leave of the officers, to have a word or two in private with her. He put his mouth to her ear, and under the pretext of a whisper, bit it clear off. This impious unnatural villany turn'd every bodies heart against him more and more. [Well good people (says the boy) here you see me an example, both upon the matter of shame and of punishment; and it is this mother of mine that has brought me to't; for if she had but whipt me soundly for the book I stole when I was a boy, I should never have come to the gallows here now I'm a man.]

THE MORAL

*We are either made or marr'd, in our education; and governments, as well as private families, are concern'd in the consequences of it.*

## AN ANT FORMERLY A MAN

THE ant, or pismire, was formerly a husband-man, that secretly filch'd away his neighbour's goods and corn, and stor'd all up in his own barn. He drew a general curse upon his head for't, and Jupiter, as a punishment, and for the credit of mankind, turn'd him into a pismire; but this change of shape wrought no alteration, either of mind or of manners; for he keeps the same humour and nature to this very day.

THE MORAL

*That which some call good husbandry, industry and providence, others call raking, avarice, and oppression : so that the vertue and the vice, in many cases, are hardly distinguishable but by the name.*

## A DAW WITH A STRING AT'S FOOT

A COUNTRY fellow took a daw and ty'd a string to his leg; and so gave him to a little boy to play withal. The daw did not much like his companion, and upon the first opportunity

gave him the slip, and away into the woods again, where he was shackled and starv'd. When he came to die, he reflected upon the folly of exposing his life in the woods, rather then live in an easie servitude among men.

**THE MORAL**

*'Tis fancy, not the reason of things, that makes life so uneasie to us as we find it. 'Tis not the place, nor the condition; but the mind alone that can make any body miserable or happy.*

## A FISHERMAN AND HIS PIPE

A FISHERMAN that understood piping better than netting, set himself down upon the side of a river, and touch'd his flute, but not a fish came near him. Upon this, he layd down his pipe and cast his net, which brought him up a very great draught. The fish fell a frisking in the net, and the fisherman observing it;

110

What sotts are these (says he) that would not dance when I play'd
to 'em, and will be dancing now without musique!

THE MORAL

*There are certain rules and methods for the doing of all things in this world; and*
*therefore let every man stick to the bus'ness he understands, and was brought up to,*
*without making one profession interfere with another.*

## A FISHERMAN'S GOOD LUCK

A FISHERMAN had been a long while at work without
catching any thing, and so in great trouble and despair, he
resolv'd to take up his tackle, and be gone : but in that very

instant a great fish leapt into the boat, and by this providence he made a tolerable day on't.

THE MORAL

*Patience, constancy, and perseverance, in an honest cause and duty, can never faile of a happy end, one way or other.*

## A LADEN ASSE AND A HORSE

AS a horse and an asse were upon the way together, the asse cryed out to his companion, to ease him, of his burden, though never so little, he should fall down dead else. The horse would not; and so his fellow-servant sunk under his load. The master, upon this, had the asse flay'd, and laid his whole pack, skin and all, upon the horse. Well, (says he) this judgment is befall'n me for my ill nature, in refusing to help my brother in the depth of his distress.

THE MORAL

*It is a christian, a natural, a reasonable, and a political duty, for all members of the same body to assist one another.*

## TWO NEIGHBOUR–FROGS

THERE were two neighbour-frogs; one of them liv'd in a pond, and the other in the high-way hard-by. The pond-frog finding the water begin to fail upon the road, would fain have gotten t'other frog over to her in the pool, where she might have been safe; but she was wonted to the place, she said, and would not remove. And what was the end on't now, but the wheel of a cart drove over her a while after, and crush'd her to pieces?

THE MORAL

*Some people are so listless and slothful, that they'll rather lie still and die in a ditch, then stir one finger to help themselves out on't.*

112

# A FATHER AND HIS SONS

IT was the hap of a very honest man to be the father of a contentious brood of children. He call'd for a rod, and bad 'em take it, and try one after another with all their force, if they could break it. They try'd, and could not. Well (says he) unbind it now, and take every twig of it apart, and see what you can do that way. They did so, and with great ease, by one and one, they snapt it all to pieces. This (says he) is the true emblem of your condition. Keep together and y'are safe, divide, and y'are undone.

### THE MORAL
*The breach of unity puts the world, and all that's in't, into a state of war, and turns every man's hand against his brother; but so long as the band holds, 'tis the strength of all the several parts of it gathered into one.*

# A LION AND A MOUSE

UPON the roaring of a beast in the wood, a mouse ran presently out to see what news : and what was it, but a lion hamper'd in a net! This accident brought to her mind, how that she her self, but some few days before, had fall'n under the paw of a certain generous lion, that let her go again. Upon a strict enquiry into the matter, she found this to be that very lion; and so set her self presently to work upon the couplings of the net; gnaw'd the threds to pieces, and in gratitude deliver'd her preserver.

### THE MORAL
*Without good nature, and gratitude, men had as good live in a wilderness as in a society. There is no subject so inconsiderable, but his Prince, at some time or other, may have occasion for him, and it holds through the whole scale of the creation, that the great and the little have need one of another.*

113

## A DAW AND BORROW'D FEATHERS

A DAW that had a mind to be sparkish, trick'd himself up with all the gay-feathers he could muster together; and upon the credit of these stoll'n, or borrowed ornaments, he valu'd himself above all the birds in the air beside. The pride of this vanity got him the envy of all his companions, who, upon a discovery of the truth of the case, fell to pluming of him by consent; and when every bird had taken his own feather; the silly daw had nothing left him to cover his nakedness.

### THE MORAL
*We steal from one another all manner of ways, and to all manner of purposes; wit, as well as feathers; but where pride and beggery meet, people are sure to be made ridiculous in the conclusion.*

## A WOLFE, A LAMB, AND A GOAT

A S a lamb was following a goat, up comes a wolfe, wheedling, to get him aside, and make a breakfast of him : Why what a fool art thou, says the wolfe, that may'st have thy belly full of sweet milk at home, to leave thy mother for a nasty stinking goat! Well, says the lamb, but my mother has placed me here for my security; and you'd fain get me into a corner, to worry me. Pray'e, which of the two am I to trust to now?

### THE MORAL
*Where there's the order of a parent on the one side, and the advice of an ill man, and a professed enemy, on the other, in opposition to that command; disobedience would be undoubtedly the ready way to destruction.*

## AN OLD WEAZLE AND MICE

A N old weazle that was now almost past mousing, try'd what she could do by her wits, when she found she could live no longer upon the square, and so conveys her self into a meal-tub

for the mice to come to her, since she could not go to them.   They came thick and threefold for a time, as she expected they should, till at last, one experienc'd stager that had baffled twenty traps and tricks before, discover'd the plot, and quite spoyl'd the jest.

<div style="text-align:center">THE MORAL</div>

*The want of force, strength, and other abilities to compass our ends must be supply'd by industry and invention.*

## A DOG AND A THIEF

A S A GANG of thieves were at work to rob a house, a mastiff took the alarum, and fell a baying: one of the company spoke him fair, and would have stopt his mouth with a crust: No, says the dog, this will not do, for several reasons.   First, I'll take no bribes to betray my master.   Secondly, I am not such a fool, neither, as to sell the ease and liberty of my whole life to come, for a piece of bread in hand : for when you have rifled my master; pray who shall maintain me?

<div style="text-align:center">THE MORAL</div>

*Fair words, presents, and flatteries are the methods of treachery in courts as well as in cottages; only the dogs are truer to their masters than the men.*

## A FOX AND A WEAZLE

A SLAM, thin-gutted fox made a hard shift to wriggle his body into a hen-roost, and when he had stuff'd his guts well, he squeez'd hard to get out again; but the hole was too little for him.   There was a weazle a pretty way off, that stood learing at him all this while.   Brother Reynard; (says he) your belly was empty when you went in, and you must e'en stay till your belly be empty again before you come out.

<div style="text-align:center">THE MORAL</div>

*Temperance keeps the whole man in order, and in a good disposition, either for thought or action, but the indulging of the appetite brings a clog, both upon the body and mind.*

116

## A BRAGGING TRAVELLER

A VAIN FELLOW that had been abroad in the world, would still be tiring all peoples ears at his return, with stories of his wonderful actions and adventures in his travels; and particularly, he told of a leap he took at Rhodes, that no body there could come within six foot on't. Now this (says he) I am able to prove by several witnesses upon the place. If this be true (says one of the company) there's no need of going to Rhodes for

witnesses: do but you fancy this to be Rhodes, and then shew us the leape.

THE MORAL

*Travellers have a kind of privilege to romance it; and to tell stories at large.   And for those that doubt the truth of the matter, they had e'en better pass it over than go to disprove it.*

## AN APE AND A FOX

AN ape that found many inconveniences by going bare-arse, went to a fox that had a well-spread, bushy tayle, and begg'd of him only a little piece on't to cover his nakedness : For (says he) you have enough for both, and what needs more than you have occasion for?   Well, John (says the fox) be it more, or be it less, you get not one single hair on't; for I would have ye know, sirrah, that the tayle of a fox was never made for the buttocks of an ape.

THE MORAL

*Providence has assign'd every creature its station, lot, make and figure; and 'tis not for us to stand correcting the works of an incomprehensible wisdom, and an almighty power.*

## A COUNTRYMAN AND A SNAKE

A COUNTRYMAN happen'd in a hard winter to spy a snake under a hedg, that was half frozen to death.   The man was good natur'd, and took it up, and kept it in his bosom, till warmth brought it to life again; and so soon as ever it was in condition to do mischief, it bit the very man that sav'd the life on't.   Ah thou ungrateful wretch! says he, is that venomous ill nature of thine to be satisfi'd with nothing less than the ruine of thy preserver.

THE MORAL

*There are some men like some snakes; 'tis natural to them to be doing mischief; and the greater the benefit on the one side, the more implacable is the malice on the other.*

118

## A FROG AND AN OXE

AS a huge over-grown oxe was grazing in a meadow, an old envious frog that stood gaping at him hard by, called out to her little ones, to take notice of the bulk of that monstrous beast; and see, says she, if I don't make my self now the bigger of the two. So she strain'd once, and twice, and went still swelling on and on, till in the conclusion she forc'd her self, and burst.

### THE MORAL
*Betwixt pride, envy, and ambition, men fancy themselves to be bigger than they are, and other people to be less : and this tumour swells it self at last 'till it makes all fly.*

**119**

## TWO FROGS THAT WANTED WATER

UPON the drying up of a lake, two frogs were forc'd to quit, and to seek for water elsewhere. As they were upon the search, they discover'd a very deep well. Come (says one to t'other) let us e'en go down here, without looking any further. You say well, says her companion; but what if the water should fail us here too? How shall we get out again?

THE MORAL

*'Tis good advice to look before we leape.*

## A HUNTED BEVER

THE bever is a kind of an amphibious creature, but he lives mostly in the water. His stones, they say, are med'cinal; and it is principally for their sake he knows, that people seek his life; and therefore when he finds himself hard pinch'd, he bites 'em off, and by leaving them to his pursuers, he saves himself.

THE MORAL

*When a greater interest is at stake, 'tis a warrantable point of honour and discretion, to compound the hazzard, by parting with the less; provided, that while we quit the one, we may save the other.*

## A SWAN AND A GOOSE

THE master of a house brought up a swan and a goose both together; the one for his eare, the other for his belly. He gave orders for the goose to be taken up, and dress'd for dinner. But the place was so dark, that the cook took one for t'other. This mistake had cost the swan her life, if she had not sung in that very instant, and discover'd her self; by which means she both sav'd her life, and express'd her nature.

THE MORAL

*A man cannot be too careful of what he does, where the life of any creature is in question.*

120

## AN EAGLE AND A DAW

AN eagle made a stoop at a lamb; truss'd it, and took it cleverly away with her. A mimical daw, that saw this exploit, would needs try the same experiment upon a ram : but his claws were so shackled in the fleece with lugging to get him up, that the shepherd came in, and caught him, before he could cleare himself; he clipt his wings, and carry'd him home to his children to play withal. They came gaping about him, and ask'd their father what strange bird that was? Why, says he, he'll tell you himself that he's an eagle; but if you'll take my word for't; I know him to be a daw.

### THE MORAL

*'Tis a high degree of vanity and folly, for men to take more upon them then they are able to go thorough withall; and the end of those undertakings is only mockery and disappointment in the conclusion.*

## AN ASS AND THE FROGS

AN ass sunk down into a bog among a shoale of frogs, with a burden of wood upon his back, and there he lay, sighing and groaning, as his heart would break : Hark ye friend (says one of the frogs to him) if you make such a bus'ness of lying in a quagmire, when you are but just fall'n into't, what would you do, I wonder, if you had been here as long as we have been?

### THE MORAL

*Custom makes things familiar and easy to us; but every thing is best yet in it's own element.*

## TRAVELLERS BY THE SEA-SIDE

A COMPANY of people that were walking upon the shore, saw somewhat come hulling toward them a great way off at sea. They took it at first for a ship, and as it came nearer, for a boat only; but it prov'd at last to be no more then a float of weeds and rushes : whereupon they made this reflexion within themselves, We have been waiting here for a mighty bus'ness, that comes at last to just nothing.

### THE MORAL

*We fancy things to be greater or less at a distance, according to our interest or inclination to have them either the one or the other.*

## A DOG AND A BUTCHER

AS a butcher was busy about his meat, a dog runs away with a sheeps heart. The butcher saw him upon the gallop with a piece of flesh in's mouth, and call'd out after him, Heark ye friend (says he) you may e'en make the best of your purchase, so long as y'ave made me the wiser for't.

### THE MORAL

*It may serve as a comfort to us in all our calamities and afflictions, that he that loses any thing and gets wisdom by't, is a gainer by the loss.*

122

# AN APE AND A DOLPHIN

PEOPLE were us'd in the days of old, to carry game-some puppies and apes with 'em to sea, to pass away the time withall. Now there was one of these apes, it seems, aboard a vessel that was cast away in a very great storm. As the men were paddling for their lives, and the ape for company, a certain dolphin that took him for a man, got him upon his back and was making towards land with him. He had him into a safe road call'd the Pyræus, and took occasion to ask the ape, whether he was an Athenian or not? He told him, yes, and of a very ancient family there. Why then (says the dolphin) you know Pyræus : Oh! exceedingly well, says t'other, (taking it for the name of a man) why Pyræus is my very particular good friend. The dolphin, upon this, had such an indignation for the impudence of the buffoon-ape that he gave him the slip from between his legs, and there was an end of my very good friend, the Athenian.

THE MORAL

*Bragging, lying, and pretending, has cost many a man his life and estate.*

# A MUSICIAN

A MAN that had a very course voice, but an excellent musique-room, would be still practising in that chamber, for the advantage of the eccho. He took such a conceit upon't, that he must needs be shewing his parts upon a publick theatre, where he performed so very ill, that the auditory hiss'd him off the stage, and threw stones at him.

THE MORAL

*A man may like himself very well in his own glass, and yet the world not fall in love with him in publick. But the truth on't is, we are partial in our own case, and there's no reading of our selves but with other mens eyes.*

123

## TWO COCKS FIGHTING

TWO cocks fought a duell for the mastery of a dunghill. He that was worsted, slunk away into a corner, and hid himself; t'other takes his flight up to the top of the house, and there with crowing and clapping of his wings makes proclamation of his victory. An eagle made a stoop at him in the middle of his exultation, and carry'd him away. By this accident, the other cock had a good riddance of his rival; took possession of the province they contended for, and had all his mistresses to himself again.

### THE MORAL

*A wise, and a generous enemy will make a modest use of a victory; for fortune is variable.*

124

# THE CONTENTS